IMAGES
of America

ASSABET MILLS
MAYNARD
MASSACHUSETTS

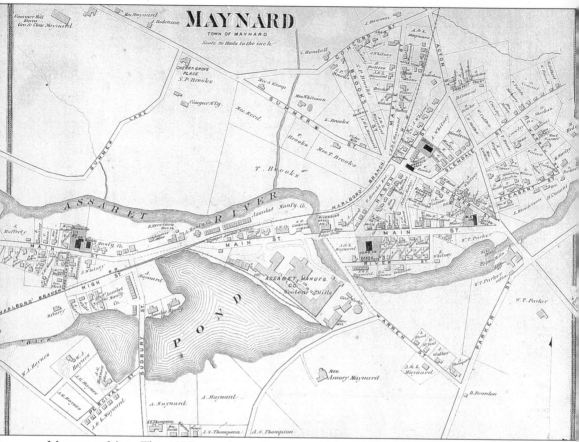

MAYNARD MAP. This 1875 map shows the town of Maynard built around the Assabet River and features the Assabet Manufacturing Company, with its large millpond drained off the river.

Cover Image: **SPINNING DEPARTMENT.** This 1901 view shows the spinning department at the Assabet Mills and some of the department's "warpers." In the background can be seen a spinning machine which draws wool woving into thin strands and twists them together with other strands to make wool yarn.

IMAGES
of America

ASSABET MILLS
MAYNARD
MASSACHUSETTS

Paul Boothroyd and Lewis Halprin

ARCADIA

Published by Arcadia Publishing,
an imprint of Tempus Publishing, Inc.
2 Cumberland Street
Charleston, SC 29401

Printed in Great Britain.

Library of Congress Catalog Card Number: Applied for.

For all general information contact Arcadia Publishing at:
Telephone 843-853-2070
Fax 843-853-0044
E-Mail arcadia@charleston.net

For customer service and orders:
Toll-Free 1-888-313-BOOK

Visit us on the internet at http://www.arcadiaimages.com

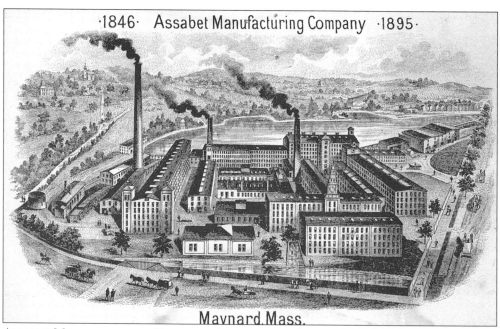

·1846· Assabet Manufacturing Company ·1895·

Maynard, Mass.

ASSABET MANUFACTURING COMPANY. A joint partnership was formed between W.H. Knight and Amory Maynard in 1846 for carrying on the carpet business at what is known now as the town of Maynard. The Assabet Manufacturing Company continued in business until 1899, when it was purchased by the American Woolen Company.

CONTENTS

ACKNOWLEDGMENTS

PAUL BOOTHROYD. I dedicate this book to my dad, Joseph Boothroyd, who spent a lifetime employed in the Assabet Mills. It was people like him who worked at the mill that made the mill complex and the town of Maynard what it is today.

LEWIS HALPRIN. One can think of this mill complex as a giant sunflower plant. It grows and flourishes, then hits a period of drought and shrivels, then gets nourished and grows again even larger and stronger. This mill is in its fourth miraculous rebirth, while most of New England's mills die after their first economic drought. I think the difference is that this mill is firmly planted within the town of Maynard, whose multi-ethnic, hard working, and well educated people provide a rich soil that encourages the mill to regrow and regain its health. My admiration goes out to this small, compact, modern town with old-fashioned values.

IMAGE SOURCES. Most of the images and caption information are from the Maynard Historical Society archives. This archive was made possible by the contributions of many residents and friends of Maynard and by the organizing efforts of longtime archivist Ralph Sheridan, who recently passed on, and current archivist Paul Boothroyd. Credit also goes to Joe Mullin for his part in writing the section on Clock Tower Place. Images in this book that are not from the society's archives are identified at the end of the image captions as follows:

(Boothroyd.) From the collection of Paul Boothroyd of Maynard.
(Case.) From the collection of Ralph Case.
(Flood.) From the collection of John Flood.
(Lancaster.) From the collection of Don Lancaster of Minuteman Airport.
(Melone.) From the Robert Melone collection.
(Monster.) From the Monster.com company.
(Mullin.) Joe Mullin from the Clock Tower Place collection.
(Powell.) From the Powell Flute Company.
(Samuels.) Alphonse Micciche from the Samuels Studio collection.
(Sarvela.) From the collection of Edwin "Sam" Sarvela.

TANK HOUSE. This two-story wood-framed building at the top of Elmwood Street was used to disguise an 18-foot-high by 20-foot-diameter iron tank, which had a capacity to store up to 42,000 gallons of pond water. This water was used by the mill for toilets and washing purposes.

INTRODUCTION

The Assabet Mills was founded by Amory Maynard, born in Marlboro in 1804 to Isaac and Lydia Maynard. Maynard's early education was limited. He spent much of his time in the sawmill owned by his father. When he was 16 years of age, his father died and he was given management of the estate. He continued the sawmill business for 25 years, becoming well known as a carpenter and builder. In 1846, the City of Boston paid $60,000 for the sawmill's water privilege and constructed a reservoir, today known as the Fort Meadow Reservoir. While searching for another site on which to locate a mill, Maynard came to tiny Assabet Village, which was then in Sudbury. He formed a partnership with William H. Knight of Saxonville and built a 50-by-100-foot wooden mill building, and there began the manufacture of carpets and carpet yarns in 1847. In its first year of operation, the mill produced $110,000 worth of carpets and yarn. Ten years later, during the business panic of 1857, the carpet mill failed.

However, the Civil War in 1861 created a demand for woolens, flannels, and blankets for the army, and producing these provided new life for the woolen mill. In 1862, the Assabet Manufacturing Company was incorporated under the laws of the State of Massachusetts, with T.A. Goddard as president, T. Quincy Browne as treasurer, and Amory Maynard as agent. Under this management and with large orders of woolen goods, the mill underwent a rapid expansion.

Attached to the mill was one of the finest waterpower systems in the state. In addition to the natural flow of the Assabet River running past the mill, there was a large storage basin of 300 acres on the other side of the mill that is controlled exclusively by the company. Later the mill obtained controlling interest in the Fort Meadow Reservoir and in Lake Boon, two nearby sources that empty upstream into the Assabet River. The mill was capable of obtaining 1,800 horsepower from this combined water flow. Its many buildings provided a total floor space of 421,711 square feet and contained 66 sets of woolen cards, 25,476 woolen spindles, and 324 looms.

The mill, under the management of the Assabet Manufacturing Company, prospered for many years. However, competition was fierce in the wool industry and by 1898, the mill had failed.

Prosperity returned once again when the American Woolen Company, an industrial giant, bought the mill in 1899 for $400,000. At that time it was the largest woolen mill in the United States, with 66 sets of cards and 350 broad looms. The American Woolen Company soon began to improve the property by replacing the old machinery with new and increasing its capacity.

Amory Maynard II, the grandson of the mill's founder, and George Hinchliffe, mill superintendent, laid the cornerstone of the new No. 5 mill on Thompson Street in July 1901. In eight short months, one of the largest single mills in the world was built. It was an incredible task to build such a gigantic structure in such a short time, especially considering the difficulties encountered in the early stages of the work. A huge ledge, which extended the entire length of

the site, delayed the laying of the foundation on that side of the mill for several weeks as the whole ledge had to be drilled and blown out. The laying of the concrete wall in the basin of the pond, which forms the foundation of a part of the mill on the waterfront, also consumed considerable time. For the first four months, work was in progress night and day, and an estimated 500 men were employed at one time during the height of the work.

When finished, the new mill building had the greatest floor space under a single roof of any textile manufactory in the world. It was 690 feet by 106 feet and 5.5 stories high. The floor space was nearly 0.5 million square feet, or 9 acres. Each floor was one large room with no dividing walls. Weekly production at this mill was 155,006 yards, and the value of the product was $7.5 million annually. The first floor was devoted to dressing, spooling, and drawing; the second floor contained all the current looms; and the third floor contained 500 of the latest Crompton & Knowles looms. It was known as a 100-set mill.

The building was completed in March 1902. With the installation of dynamos in the new power plant, electricity became available. On September 1, 1902, a contract was made between the American Woolen Company and the Town of Maynard for the lighting of the town streets.

Amory Maynard II retired in October 1902. He was the last of the Maynard family connected with the Assabet Mills. Others family members involved were founder Amory Maynard until 1855, his son Lorenzo Maynard, William Maynard, and William Maynard II.

Construction continued at a good pace during the early 1900s. In 1904, No. 6 mill was built. In 1905, a new office for the mills was built on Main Street. In 1911, work started on a new 100-by-50-foot, four-story storehouse out over the millpond. In August 1913, the dam and sluiceway at the "old" paper mill were rebuilt. The Assabet Manufacturing Company had purchased the paper mill property in 1895. In 1916, a 200-foot, hollow-brick chimney was built near the red brick chimney, which remained until torn down in 1956. In 1918, the 500-foot-long No. 1 mill was built over the millpond and a steam turbine engine was installed.

The Great Depression of 1929 placed a serious pinch on the American Woolen Company and the mills. Labor troubles also haunted the company. In October 1931, the mill closed and all 1,200 employees were locked out, causing hard times in the town of Maynard.

Once again, a war saved the mill. In 1941, when World War II began, Assabet Mills was soon producing on a 7-day week, 24-hour day basis, employing over 2,000, making blankets, overcoats, and suits for the armed forces.

Following the close of this war, the mills became a casualty of the shifting public taste in textiles. No longer were soft woolens such as were made by the mills in fashion. People wanted the hard woven worsteds. Also, synthetic materials such as rayon, nylon, dacron, and polyester were making inroads in the cloth manufacturing business. In the early fall of 1950, the American Woolen Company closed the mills for good.

In 1953, ten Worcester businessmen bought the mill, formed Maynard Industries, and began leasing space to tenants. Some of the mill's tenants were established firms; others were just getting started. One of the new companies that found the low cost of Maynard Industries' space appealing was Digital Equipment Corporation, which started operations in 1957, using 8,680 square feet of the mill. Ken Olsen, who attended Massachusetts Institute of Technology and worked there as an engineer, wanted to start a company that would use new transistor technology to build a small minicomputer rather then the large computers that were most common at that time. Olsen found the price at Maynard Industries unmatched at any other site: for space at Building No. 12, the second floor was 25¢ per square foot and the third floor was 15¢ per square foot. Olsen also found an ample supply of hard-working people in the town of Maynard. As Digital products became successful, the company grew and moved into space available in the mill buildings. In 1974, Digital bought the entire mill complex and took over all the space used by other firms at the mill as their leases ran out. Besides completely occupying the mill complex, Digital constructed several additional campuses of buildings in and around Maynard to house activities. The computers that Digital produced were the forerunners of today's microcomputers, and the town of Maynard became known as the Minicomputer Capital

of the World because of Digital's presence.

As with the Woolen companies, competition with Digital's primary product became very strong, and the microcomputer began to displace the minicomputer in the marketplace. In 1997, Digital Equipment Corporation was purchased by Compaq Computer, a Texas manufacturer and the mill facilities were soon vacated.

Many potentials for the use of the mill complex were considered. One of the most promising was by a group called Franklin Live Care to convert the buildings into a large collection of assisted-living apartments, with full-care and nursing facilities. After initial plans were completed, the project ran into financial problems and was discontinued. The mill's future was still unresolved.

In January 1998, Wellesley/Rosewood Maynard Mills Limited partnership became the owner and manager of the 150-year-old Maynard Mills complex, with its 13 buildings and 1.1 million square feet of space. The new owners named the complex Clock Tower Place for the large tower clock, which was given to the town by Lorenzo Maynard in memory of his father Amory Maynard.

The owners converted the old Digital offices into first-class, technically modern industrial and office spaces, which they rented to small companies and to new companies—just as Maynard Industries once rented unused mill space to a new company called Digital Equipment Corporation.

At the beginning of the 20th century, the mill buildings held the world's-largest producer of products made from wool. In the 1980s, the mill buildings held the largest minicomputer manufacturer in the world. At the end of the 20th century, the mill buildings, one of the ten largest commercial-industrial complexes in Massachusetts, is poised for the next great user to arrive.

Mill Time Line

1846: Amory Maynard and William Knight form Assabet Mills, world's largest woolen factory until 1930s.

1847: Maynard and Knight install waterwheel and build new factory on Assabet River.

1848: Assabet Mills business valued at $150,000.

1855: Three buildings on site; Massachusetts produces one third of the nation's textiles.

1857: Assabet Mills liquidates and is sold at auction after crippling business panic.

1862: Assabet Mills reorganizes as Assabet Manufacturing; new construction and new machinery and new tenements for employees; production switch from carpets to woolen cloth, blankets, and flannels for Civil War needs.

1869: Mill hands petition President Grant for shorter work week of 55 hours.

1871: Maynard incorporates; population of 2,000 English, Irish, and Scottish descendants work in mill, dawn to dusk.

1888: Reservoir installed for $70,000 for growing population.

1890: Assabet Manufacturing business valued at $1.5 million.

1892: Lorenzo Maynard donates mill clock in father's name.

1898: Assabet Manufacturing declares bankruptcy; mill hands lose half their savings since banks not yet established.

1899: American Woolen purchases complex for $400,000; growth and improvements over next 25 years.

1901: Mill erects 160 tenements on streets named after U.S. presidents, with own sewage system; First electric trolley in Maynard.

1901: Mill's largest building, No. 5, built in nine months; dynamos installed, electric power introduced.

1906: Six new structures added to mill complex since 1892.

1910: American Woolen occupies 421,711 square feet on 75 acres.

1918: Three new buildings added to mill complex since 1906.

1920: Mill declines; doors close in 1950.

1947: Mill phases out wool production as demand for woolens declines.

1950: Mill closes; 1,200 lose jobs; 11-acre site lies empty.

1953: Maynard Industries buys mill for $200,000, rents to business and industrial tenants.

1957: Three engineers form Digital Equipment with $70,000 on 8,600 squarer feet of space, second floor, Building 12.

1960: Town recovers, mill revives as 30-plus companies locate in complex.

1974: Digital buys 1 million-square-foot mill complex on 11 acres for $2.2 million in stock.

1994: Digital moves from mill to more modern facilities around New England.

1994: Mill complex purchased by Franklin Health Care with plans to convert mills homes for seniors.

1998: Franklin unable to obtain financing, sells mill to Clock Tower Place with plans to upgrade and lease space to industry.

1999: Clock Tower Place leases 40% of mill buildings to 40 companies.

One

ASSABET
MANUFACTURING
COMPANY

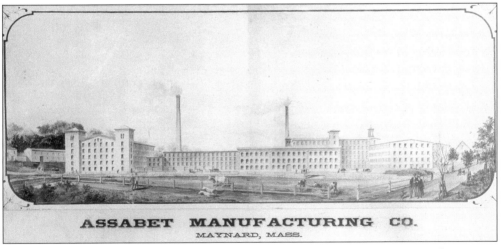

ASSABET MANUFACTURING COMPANY 1870 ASSESSOR'S VALUE. In 1870, the Sudbury Town Assessor (the mills were in the town of Sudbury at that time) valued the Assabet Manufacturing Company at $255,000.

Houses (3) @ $4,100	Cottages (2) @ $1,800	Cottage house (1) @ $800
Boardinghouse #1 @ $1,300	Tenement block #1 @ $5,000	Shase's house @ $1,100
Boardinghouse #2 @ $3,300	Tenement block #2 @ $4,800	Sweeney's house @ $450
Boardinghouse #3 @ $2,000	Tenement block #3 @ $2,400	Proudman's house @ $800
Boardinghouse #4 @ $3,500	Tenement block #4 @ $7,000	Lorenzo's house @ $1,600
Store @ $3,000	Stable @ $300	Barn @ $600
Gashouse @ $2,000	Freight house @ $2,500	Sawmill @ $3,500
Factory blgs @ $68,000	Cards (34 sets) @ $120,000	Land/water @ $15,150

AMORY AND MARY (PRIEST) MAYNARD. Amory Maynard was born in Marlboro in 1804 to Isaac and Lydia Maynard. His early education was limited.

He worked on his father's farm, but much of his time was spent in a sawmill in Marlboro owned by his father. When he was 16 years of age, his father died and he was given management of the estate. He continued the mill business for a period of 25 years, during which time he became quite widely known as a carpenter and builder. At one time he had 60 men in his employ erecting mills, houses, and other buildings in Marlboro, Concord, Framingham, and neighboring towns. In 1846, the city of Boston purchased the sawmill's water privilege and spent $60,000 in the construction of a reservoir, today known as the Fort Meadow Reservoir. While searching for another site on which to locate a mill, Maynard came to little Assabet Village on July 2, 1846, which was then in Sudbury. At that time there was no good road through the place and it had but 14 dwellings. Maynard formed a partnership with W.H. Knight of Saxonville in the same year, built a 50-by-100-foot woolen mill, and began the manufacture of carpets and carpet yarns for the Boston market. Maynard repurchased the Fort Meadow Reservoir property, which was no longer needed by Boston, along with several hundred acres of land in its vicinity c. 1859. He used the reservoir as a reserve water supply for the woolen mill.

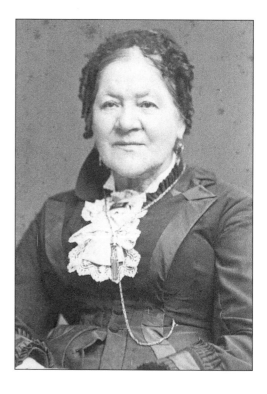

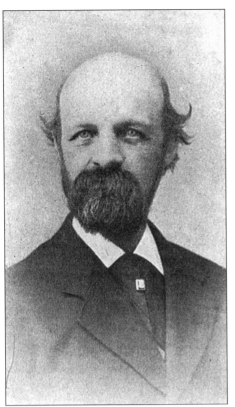

LORENZO, WILLIAM, AND AMORY MAYNARD. The first member of the Maynard family connected with the Assabet Mills was Amory Maynard, after whom the town was named. When he retired in 1855, his son Lorenzo Maynard became the mill's superintendent. Lorenzo Maynard was very active in town affairs and held several town offices. After the failure of the Assabet Mills, he moved to Winchester where he died on March 13, 1904. His brother William Maynard also held a management position at Assabet Mills. Amory Maynard II, son of William Maynard, retired in October 1902 from his management position at the American Woolen Mills, thus ending the Maynard family mill connection. Shown above, from left to right, are Lorenzo Maynard, his brother William Maynard, and William Maynard's son Amory Maynard II.

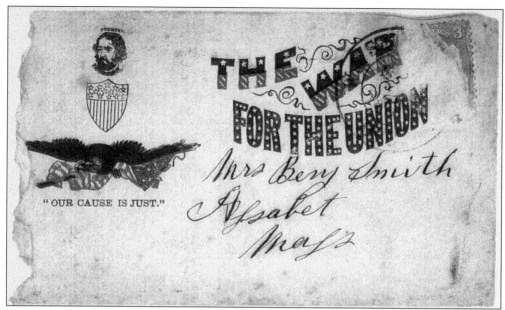

CIVIL WAR LETTER. The Civil War in 1861 created a demand for woolens, flannels, and blankets for the army, and producing these provided new life for the woolen mill. In 1862, the Assabet Manufacturing Company was incorporated under the laws of the State of Massachusetts, with T.A. Goddard as president, T. Quincy Browne as treasurer, and Amory Maynard as agent. Under this management and with large orders of woolen goods, the mill underwent a rapid expansion. (Case.)

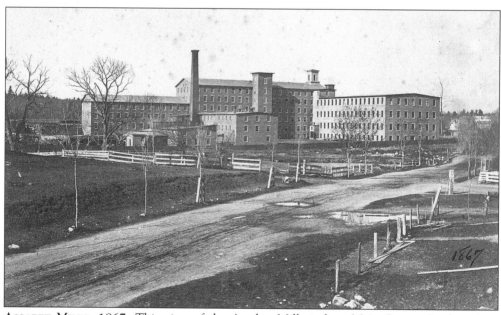

ASSABET MILLS, 1867. This view of the Assabet Mills is from Main Street. At that time, Walnut Street was on the southern side of the river and ran from Main Street to Thompson Street. In 1872, the street was relocated on the northern side of the river, running from Main Street to Parker Street, and an iron bridge was built across the river on Walnut Street.

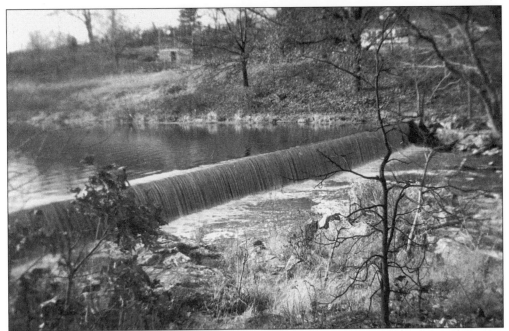

BEN SMITH DAM. The mill used waterwheels for power starting in 1847, after the Ben Smith Dam was built across the Assabet River and a canal was dug to channel part of the water into a reservoir, the present millpond. The dam created a large basin in the river above it, which became a popular area for boating, swimming, fishing, skating, and other recreation.

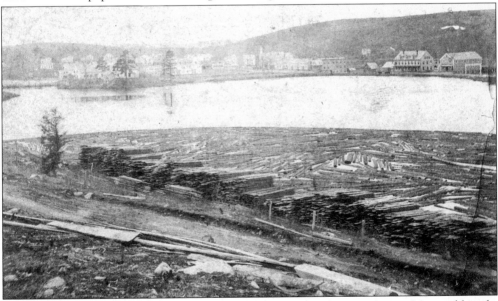

MILLPOND. In order to make the river a more stable source of power, Amory Maynard bought from Haman Smith a strip of land connecting the river to the mill area. Artemas Whitney, a close associate of Maynard's, dug a canal that led the water to what was then a low, swampy hollow with a trout brook running through it. Whitney cleared the land and built a temporary earth dam that allowed water into the millpond by way of the canal. This picture shows logs floating in the pond, waiting to be milled for constructing the mill buildings.

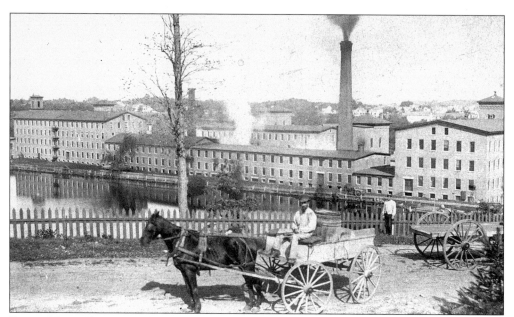

EARLY MILL. This view is from Thompson Street in 1881. Building No. 3 has been lengthened but not yet raised to six stories throughout. Building No. 4 is at the right. Members of the founding Maynard family lived on the hill just behind the photographer.

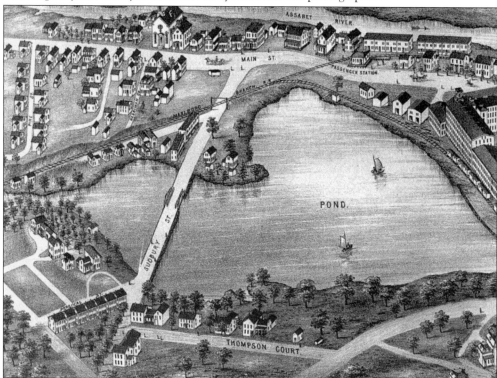

SURROUNDING TENEMENTS. The mill's business was so successful that streets were laid out and houses and tenements for the employees were erected. This 1879 drawing shows a portion of the mill at the far right, with the attached millpond and many of the mill employee's housing.

NOTICE.

Proof of **INTOXICATION** of any operative in the employ of this Company, will be sufficient cause for immediate discharge.

March 11, 1879. L. MAYNARD, Supt.

NO DRINKING. Lorenzo Maynard had zero tolerance for his employees being intoxicated, whether working or not.

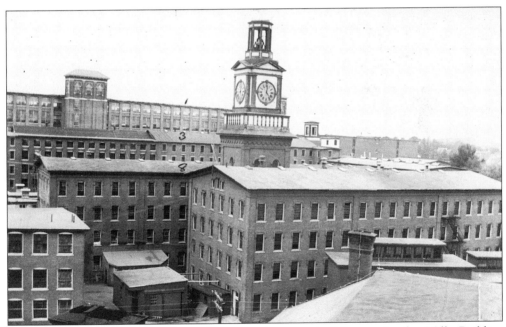

ASSABET MILLS, 1931. This picture shows two four-story buildings at Assabet Mills: Building No. 8, 42 feet by 200 feet, with a total of 8,400 square feet of space, built in 1870; and Building No. 11, 60 feet by 150 feet, with a total of 9,000 square feet, built in 1893.

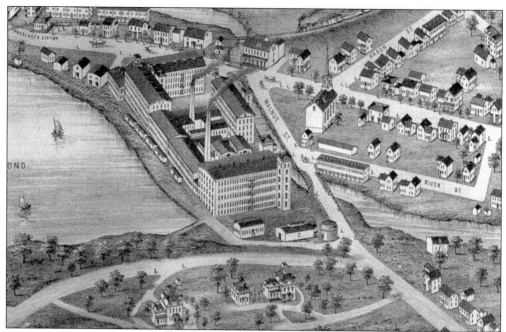

MILL TERRITORY. Industries, such as those in Assabet Village, developed near the river in order to make use of its waterpower. Commercial and residential counterparts soon located near the industries in order to supply goods and services. This 1879 picture shows an aerial view of the woolen mills in Maynard and much of the industry and residential development that took place around the mill.

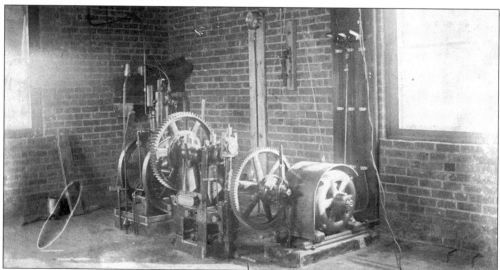

REPLACING OBSOLETE EQUIPMENT. In 1862, the mills became the Assabet Manufacturing Company with T.A. Goddard as president, T. Quincy Browne as treasurer, and Amory Maynard as agent. The small wooden buildings were replaced by brick buildings of enlarged capacity. New machinery was installed, and the manufacture of carpets changed to the manufacture of blankets, flannels, and woolen cloth. The Civil War was in progress with large government orders to be filled, which enabled the company to undertake extensive expansion, including new streets and tenement housing for its employees.

18

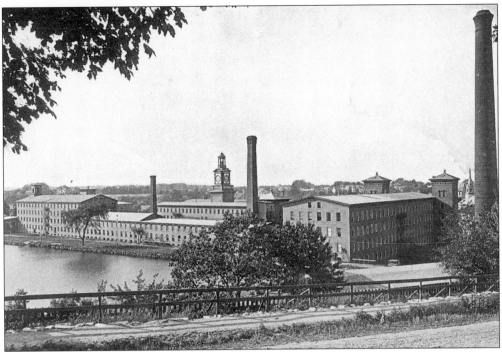

WOODEN PREDECESSORS. The original mill was a wooden structure. Afterward, a six-story, 170-by-50-foot brick mill was built over the wooden frame while the machinery inside was still running. The following mill buildings were also significant: No. 1 (124 by 70 feet, four-floors, erected 1866), No. 7 (225 by 60 feet, five floors, erected 1872), No. 5 (157 by 50 feet, four floors, erected 1868), No. 8 (200 by 45 feet, four floors, erected 1872), No. 6 (60 by 30 feet, two floors, erected 1872), No. 26 (150 by 60 feet, four floors, erected 1892).

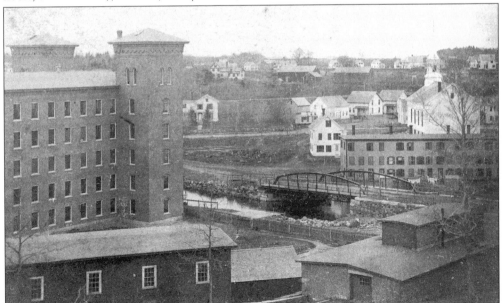

ASSABET MILLS, 1872. This view shows the iron bridge on the newly located Walnut Street. Note that the Maynard block, or Masonic building, had not yet been built.

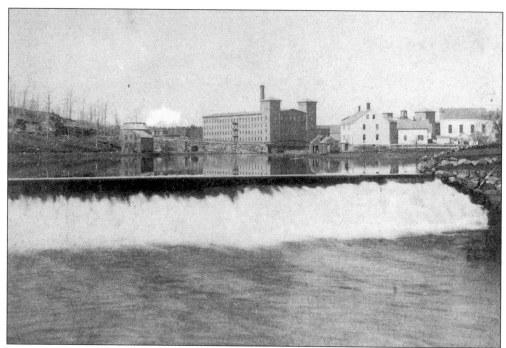

PAPER MILL DAM. Until 1927, the dam was located south of where the Assabet River runs under the Paper Mill Bridge. Both the dam and bridge were washed out in November 1927. The bridge was replaced.

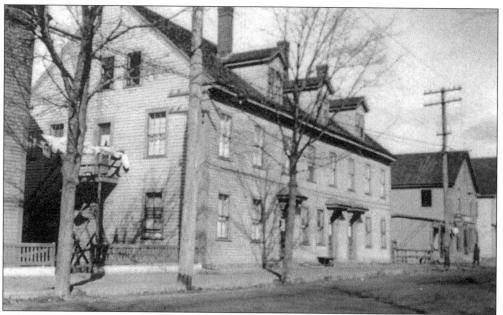

FORMER MILL BUILDING. Assabet Mills was granted a charter of incorporation by the Massachusetts General Court in 1849. In 1855, the industry was contained in three wooden buildings and consisted of 11 worsted combers, 4 sets of cards, and 52 hand carpet looms, and it employed 125 workers. One of these original buildings was used as a wool shop and later moved to 165-169 Main Street, where it was made into an apartment house.

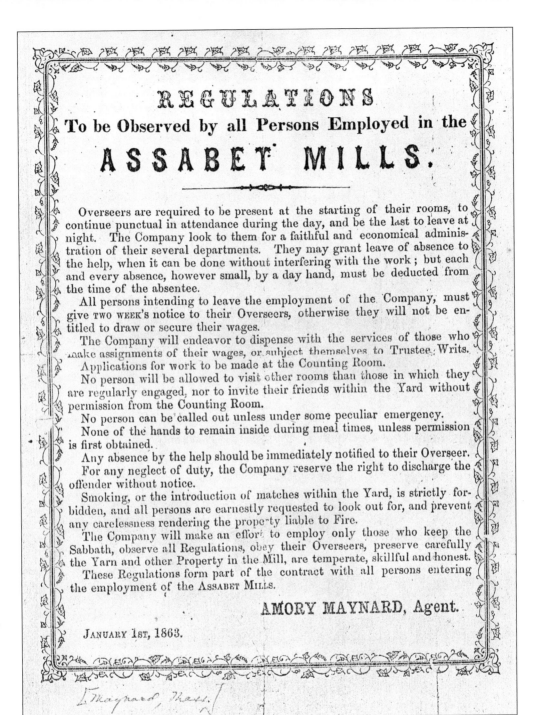

NOW HEAR THIS. Mill workers were wrapped up in regulations that affected most of their activity while working and even after work.

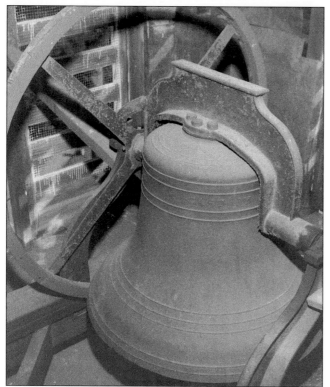

CURFEW BELL. This bronze curfew bell, cast in England in 1856, signaled to the mill employees that by 9 p.m. each night they were to be at home and in bed. Employer Amory Maynard warned that any of his employees found on the streets after the bell tolled would lose their jobs. In October 1935, Matti Katvala, a watchman for the American Woolen Company and a member of the Finnish Congregational Church, heard that the mill's curfew bell was going to be given away. He asked the mill superintendent, Mr. Templeton, if the company would give this famous and historic bell to his church. His request was granted, and the bell was hung in the belfry of the Finnish Congregational Church.

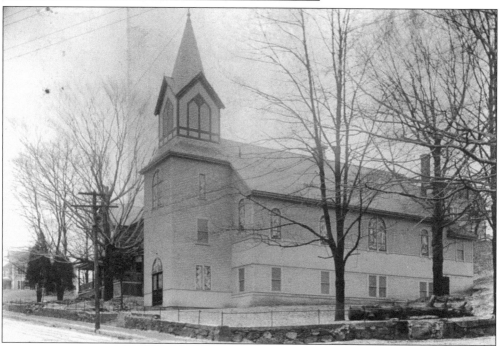

FINNISH CONGREGATIONAL CHURCH. This church was built at the corner of Walnut and Thompson Streets, and its cornerstone was laid on May 23, 1923. Its bell tower contains what used to be the curfew bell at the American Woolen Mills.

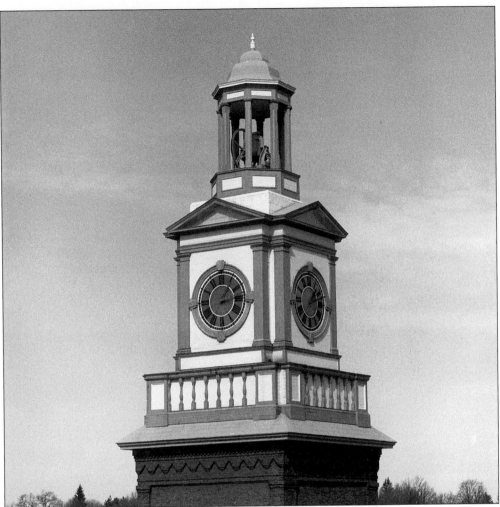

TOWN CLOCK. The Assabet Manufacturing Company tower clock was given to the town in 1892 by Lorenzo Maynard. The wooden tower, built over a brick base, was painted white with a brick red trim. The clock was made by the E. Howard Clock Company of Waltham. The stairway to the tower, which is 85 feet from the ground, has 124 steps. The wooden tower floor is 12 feet across, with the clock mechanism in the middle of the tower. There are two sets of cables and weights, one for the timer and one for the striker. The 8-day mechanism requires 90 turns of the hand-operated crank to wind the timer and 330 turns to wind the striker. Each 9-foot diameter clock face fits within a 12-foot tower wall and is lighted by five 60-watt bulbs.

FACTORY OUTLET. Products of the Assabet Manufacturing Company were sold at the factory directly to retailers, as well as to townspeople.

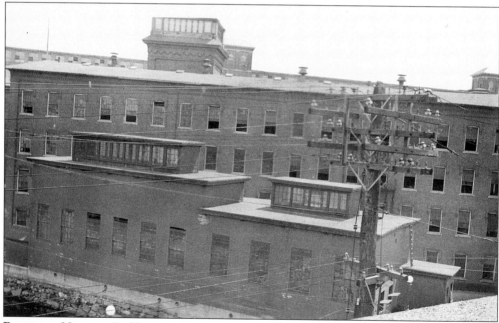

BUILDING NO. 11. Building No. 11, built in 1893, is four floors high, 60 by 150 feet, and contains 9,000 square feet of floor space. The 53 by 25 foot garage in the foreground, with 1,335 square feet of space, was eventually torn down to make easier access to the buildings.

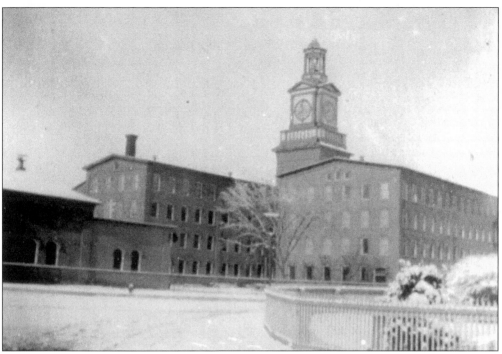

RIVER VIEW. This view of the Assabet Mills with the tower clock was taken from River Street in the late 1800s. The fence in the foreground surrounds the Masonic building next to the mill.

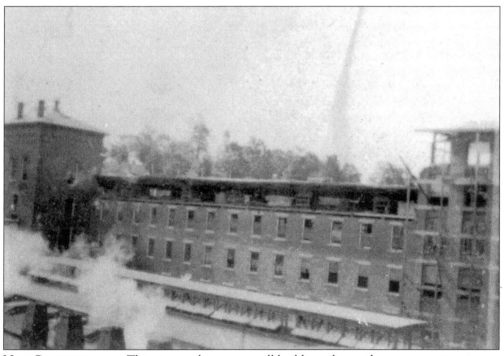

NEW CONSTRUCTION. This picture shows new mill buildings during their construction.

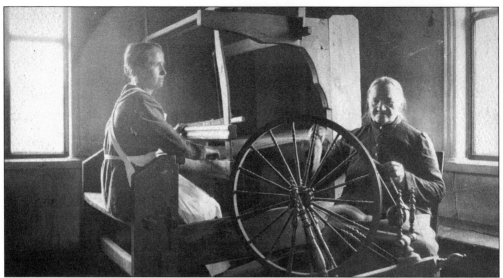

SPINNING AND WEAVING IN THE MILL. Introduction of the spinning wheel was the first major step towards the mechanization of spinning. A great mechanical advantage was obtained by mounting a small pulley on the spindle and driving it with a large wheel, since one turn of the wheel rotates the spindle dozens of times. One end of a roll of carded wool, such as that produced by the Dryden carding machine, is attached to the spindle. Holding the other end of the roll in her left hand, the spinster draws it away from the spindle. At the same time, she turns the wheel with her right hand. As the spindle turns, the roll of wool is twisted into yarn, the thickness of which is determined by the drawing. When drawing and twisting are completed, the spinster has 4 or 5 feet of yarn which is then wound onto the spindle. A new roll of wool is attached, and the process is repeated. (Sarvela.)

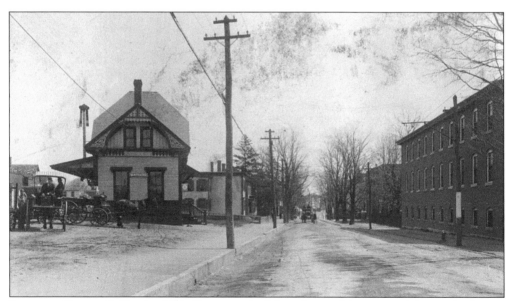

SLEEPING GIANT. Still quiet, Main Street awaited the advent of the automobile, at which time it came alive and moved into the 20th century. The train station is shown on the left with one of the mill buildings on the right.

Two

AMERICAN WOOLEN COMPANY

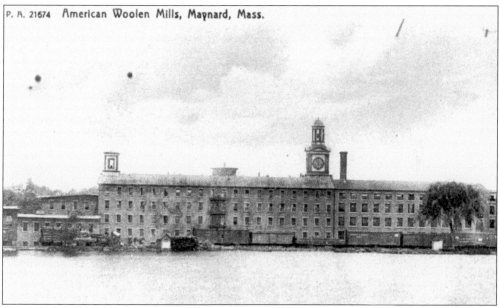

P. A. 21674 American Woolen Mills, Maynard, Mass.

AMERICAN WOOLEN MILLS. The American Woolen Company was organized as a typical old-time trust. By 1900, its first full year, it operated 26 mills, one of them in Maynard. By 1923, it reached a total of 57 mills. Charles Rawlett was its presiding financial genius. Frederick Ayer, a major seller of sarsaparillas and patent medicine, transferred his fortune to the American Woolen Company because textiles were considered more respectable than beverages. However, the real operating head of the company and its president from 1905 through 1924 was William Madison Wood.

WILLIAM MADISON WOOD. William Madison Wood was born on April 5, 1861, at Edgartown on Martha's Vineyard. He was a high-pressure, go-getter salesman and builder who became the president of the American Woolen Company between 1905 and 1924, running the company strictly as a one-man show. Although the company made significant profit during World War I, as well as World War II, it never became the empire Wood was aiming for. The company joined the rest of the woolen industry in a slow demise. With failing health and a failing company, Wood ignored 24 successful years that lay behind him and took his own life in 1926.

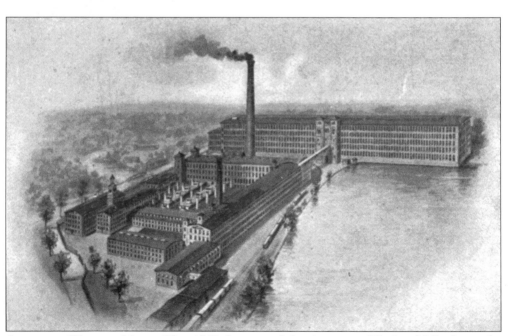

AMERICAN WOOLEN MILLS. This 1905 drawing of the American Woolen Mills shows the magnitude of this enormous facility residing next to the Assabet River in the town of Maynard.

SHAFTS AND BELTS. At first, the traditional wooden waterwheel was the prime mover in the Mill. Power was transmitted to the machines in different parts of the mill buildings by an intricate series of shafts and belts.

WATER TURBINE. With the introduction of water turbines, a stream of water from a pipe is discharged against the metal blades of a turbine, causing it to rotate at high speed. The turbine was far more efficient than the old-fashioned waterwheel and less dependent on the water level of the river.

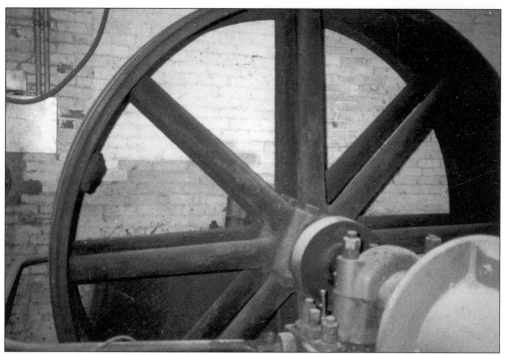

STEAM ENGINE. Steam was a more reliable source of power and by 1879, nearly 40% of the total horsepower in American Woolen Mills was generated by steam. One advantage of steam was that mills were no longer required to be situated near a waterfall. (Boothroyd.)

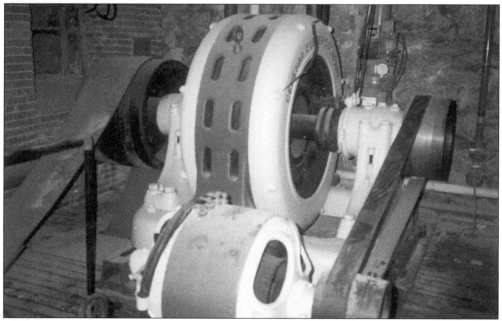

ELECTRIC POWER. In 1889, the mill had its own illuminating gasworks that were replaced after the end of the 19th century by a coal-fired electric generating plant. The complex system of shafts and belts once used to distribute power from a central source was replaced by smaller, more efficient electric motors. (Boothroyd.)

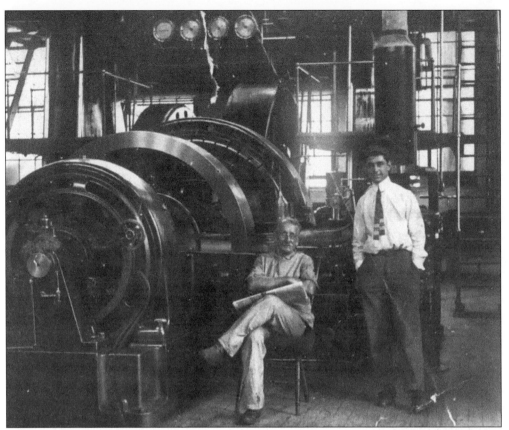

POWERHOUSE. From 1889, the mill had its own illuminating gasworks, which were replaced in 1902 by more efficient electric motors.

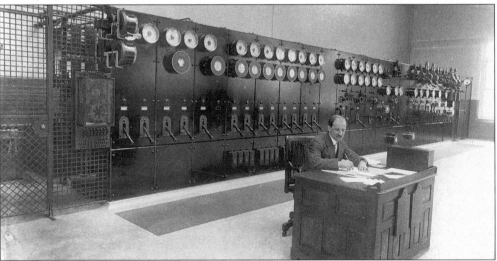

DYNAMO CONTROL ROOM. With the installation of a dynamo in the new power plant, electricity became available and on September 1, 1902, a contract was made between the American Woolen Company and the Town of Maynard for lighting the streets of the town. Thus, the old kerosene lamps passed into oblivion.

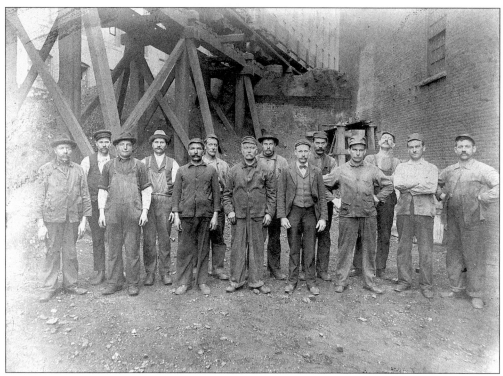

BOILER ROOM WORKERS, 1905. Coal was the main source of power for the mill complex in the early 1900s. The coal was brought to the mill by train and was unloaded and shoveled into the boilers by these workers.

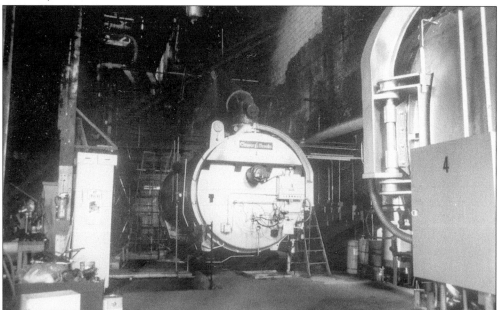

LARGE BOILER IN BOILER ROOM. Installed in the boiler room, this is one of the large boilers that was used to heat the mill buildings. The boilers could be fired by either gas or oil with an easy conversion.

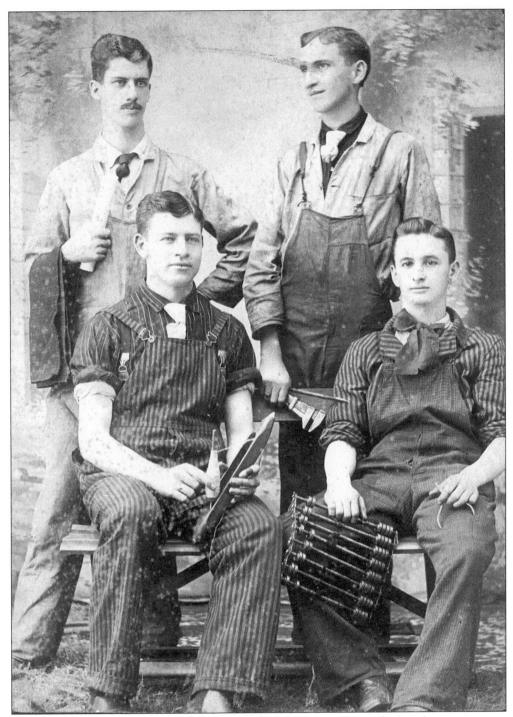

WEAVE ROOM. These four employees are some of the many who worked in the weave room. They are, from left to right: (front row) W. Smith and H. Maynard; (back row) W. Denniston and J. Brayden. Accidents frequently occurred in the weave room, such as when a worker was hit by a runaway shuttle.

HILLSIDE STREET CARPENTER SHOP. The carpenter shop on Hillside Street was a 48 by 40 foot building with weathered shingles, a tar paper roof, and a dirt-floored basement.

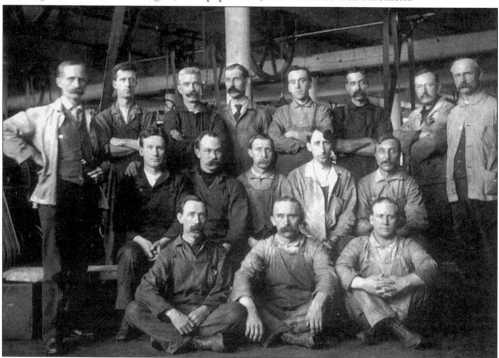

CARPENTER SHOP EMPLOYEES. In 1901, an American Woolen Mills piper named Thomas Cuttell was standing near an elevator that was loaded with pipes. As the elevator started to descend to a lower floor, Cuttell thoughtlessly leaned over the gate to watch in its downward course. In an instant, the roof of the elevator came down upon the back of his neck, pinning him between the roof and the gate. The screams of a co-worker caused the elevator operator to immediately reverse the elevator and bring it back up to the floor from which it started. Cuttell's neck was badly swollen and he had some cuts, but he escaped death because of the very fast reactions of his co-worker and the elevator operator.

UNION REPRESENTATION. Because of the cyclical nature of the textile industry, on top of the periodic recessions and depressions of the American economy, it was inevitable that labor turmoil would take place. Wages and working conditions were bones of contention, and various labor unions were formed. The skilled workers were the first to organize. The spinners, who had organized in a union during the days of the Assabet Manufacturing Company, reorganized in their local in 1902. This was followed by the loom fixers, mule fixers, mule spinners, and weavers during the ensuing decade, either as independent locals or part of the American Federation of Labor. The company had a very simple strategy for stalemating union activity: divide and conquer. The ethnic groups in the mill were used against each other, as witnessed in the strike of 1911 in the stripping department. This department's Finnish employees were fired and replaced by Poles. This method succeeded time after time as the ethnic groups, each speaking their own language and very little English, were naturally not on speaking terms. By 1916, most of the departments were organized into the American Federation of Labor. (Boothroyd, both photographs.)

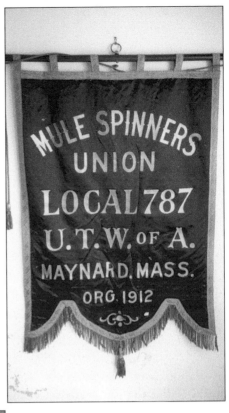

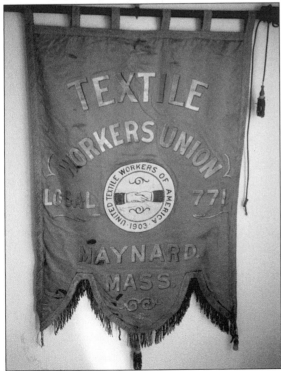

WORLD WAR I GARDENS. This photograph shows the plowing of the American Woolen Company field off Thompson Street for war vegetable gardens. This field is the present site of the mill parking lot, formerly called the hay field.

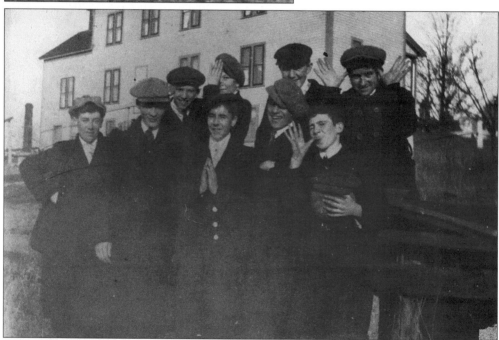

AFTER HOURS. Woolen mill employees enjoy some after-work camaraderie. They are, from left to right: (front row) Ed King, Jack Kane, Ed McManus, Ralph Sheridan, and John Hoffman; (back row) Ed Hoffman, George Peterson, Anton Peterson, and Bob Sheridan. The photograph was taken c. 1916 in the Thompson Street field, which is now a parking lot.

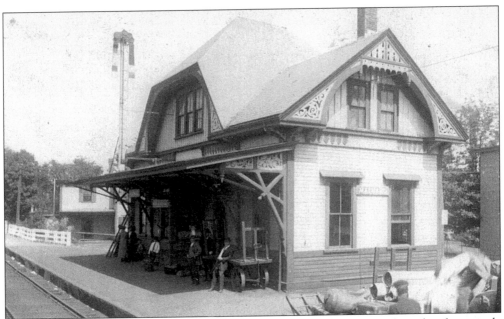

B&M RAILROAD STATION IN MAYNARD, 1900. The stationmaster's job at this deceptively small railroad station was enough to wear out the stationmaster within a few months of taking on the job. In addition to serving as ticket master, the stationmaster acted as the freight agent, telegraph operator, and baggage master. The freight business, normally about $3,000 per month, increased to $16,000 because of the extensive building operations under way at the American Woolen Mills. There were 65 cars on the Maynard tracks, 52 at the South Acton Station awaiting room in Maynard, and 34 more en route from Fitchburg. Even more traffic came later as work started on the construction of 65 houses the American Woolen Company built in Maynard.

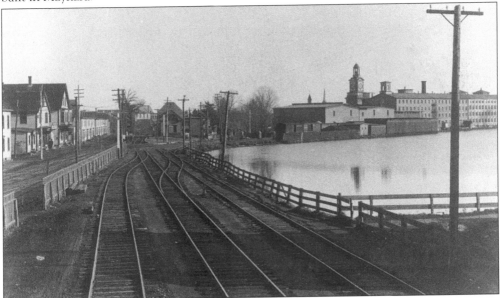

RAILROAD YARD. Trains ran daily through Maynard on the Boston & Maine line from Acton to Marlboro. The rail line was discontinued in 1939.

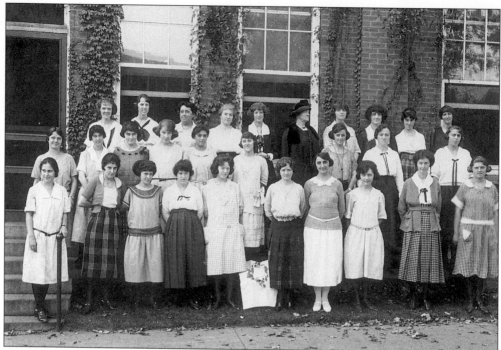

ASSABET MILLS OFFICE EMPLOYEES, 1922. This photograph shows some of the mill's office workers, from left to right: (front row) Mae Donahue, Dorothy Sheridan, Mildred Randall, Sadie Mallinson, Dorothy Wilder, Eva Tucker, Margaret McCormack, Mary Darcy, Gertrude Morgan, and unidentified; (middle row) Marion Gault, Laura Parkin, Rachel Gates, Mildred Jones, Ellen Morris, Hazel Easthope, Alice Connors, Viola Binks, and unidentified; (back row) Charlotte Gault, Viola Sales, Laura Woodart, Margaret Gates, Lucille Sims, Doctor White, Lena Whitney, Irene O'Donnell, Margaret Dunn, and Myrtle Sims.

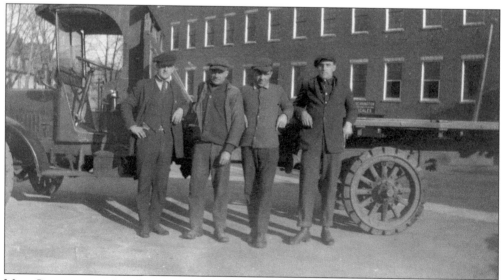

MILL CHAUFFEURS. Standing in front of the mill's bus are the mill's four chauffeurs, from left to right: Connie Moynihan, William Duckworth, Ed Johnston, and Roy Gray.

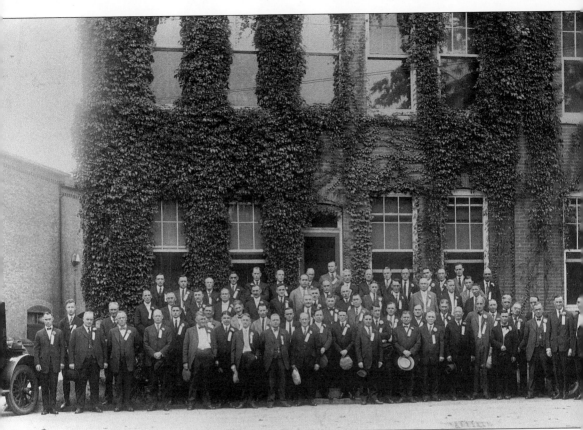

AMERICAN WOOLEN MILLS OVERSEERS, 1921. The bosses of all the various departments at the Assabet Mills gather together for an official picture. Who's running the store? The overseers are, from left to right: (first row) Harry Burnham, James Morgan, Everett Troup, Charles Courtney, Charles Keene, Joseph Donahue, Albert Easthope, Thomas Wright, Harry Rodway, Frank Coulter, unidentified, Gavin Taylor Sr., unidentified, William Brayden, ? Columbo, Richard Murphy, Herbert Brayden, and William Mann; (second row) Albert Dreschler, Richard Parmenter, Arthur Dawson, George Champane, George Morse, George Cogswell, Luke McCarthy, Oliver Trees, Leo Downey, unidentified, Fay Graham, unidentified, John Lawton, Mike May, Jack Sheridan, and Irvin Dart; (third row) Robert Archer, unidentified, James Frazer, Irving Howe, John Miller, Frank Brayden, ? King, unidentified, unidentified, Nick Kane, Wallace Priest, Daniel Conors, Joseph Byrne, Thomas Dean, Robert Dennison, unidentified, and Wilbur Hamblin; (fourth row) William Stockwell, William Dyson, John Weaving, William Hinds, Arthur Jordan, Joseph Marsden, Frank Goettler, unidentified, William Johnson, Fred Hayward, Everett Troup, Gerald Dowen, Harry McKenna, William Ingham, George Stockwell, and Alan Howard. At top is Oswald Dreschler, agent.

GIANT NEW BUILDING. Construction of mill Building No. 5 was started in July 1901. Agent Amory Maynard II and George Hinchliffe, superintendent, assisted in laying the first stone of the new No. 5 mill on Thompson Street. This building, when completed, was the largest woolen mill in the United States: 690 feet long, 106 feet wide, and 5.5 stories high. The powerhouse added 50 more feet. It housed the largest loom and the largest number of looms, 100 sets, in the world. The new building required more than 200 cars to carry the lumber used in its construction, and the window frames filled an additional 11 cars. The weights for the windows weighed a total of 50 tons. The large engine installed in this building was powerful enough to furnish both mechanical power and all the electricity needed for the entire plant.

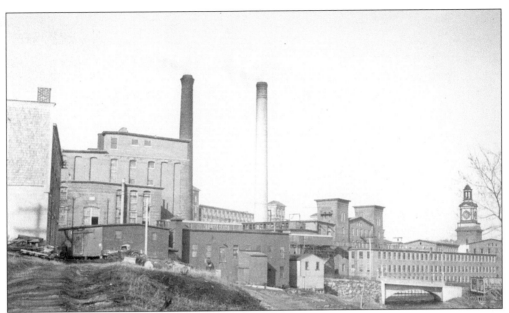

HILLSIDE STREET VIEW. This view of the mill is from Hillside Street. The carpenter shop is on the left, and some of the early mill buildings are in the forefront. On August 17, 1920, four horses, a barn, and a storehouse located on Hillside Street burned in a fire with estimated losses of $75,000. The barn was half of the original Lorenzo Maynard barn, which had been moved from Maynard's Hill. One of the storehouses is said to have been the old original mill building of 1846, moved to this location in 1901.

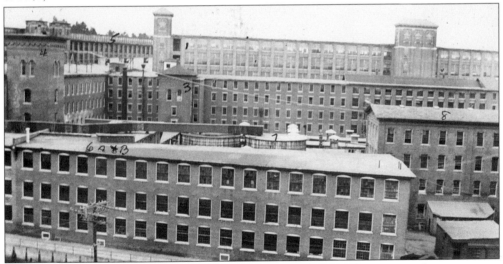

WOOLEN MILL LOSING MARKET. When American Woolen was first organized, women wore woolen underwear and woolen or cotton dresses. Silk was still a luxury, and rayon was unknown. Then came short skirts and rayon and silk, and women's clothing became much lighter. A silk dress that costs $15 would cost $22 if made of wool. Woolen underwear was replaced with cotton, silk, or rayon. The woman who wore 6.4 yards of wool in 1909 wore only 0.58 yards in 1929. The country consumed only 167.6 million pounds of raw wool in 1934 as compared to 312.8 million pounds in 1922, while rayon consumption increased from 25 million to 200 million pounds. (From a 1935 trade magazine.)

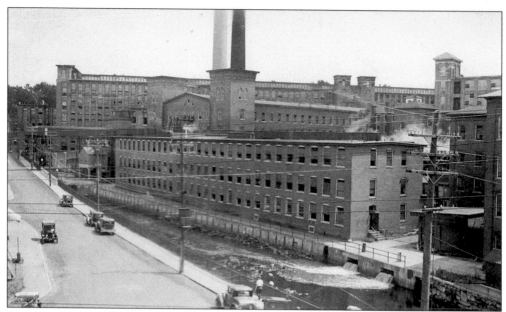

WALNUT STREET VIEW, 1931. Although wool was still the material of choice for men's suits, the Depression resulted in fewer suit sales. In 1926, the yardage of cloth for men's wear was enough to make 26.6 million suits. In 1933, it was enough to make only 18 million suits, a decline of 33%. In other words, in 1926, a new suit was bought every 1.5 years whereas in 1933, a new suit purchase was made every 2.5 years. As a result, the wool industry operated in a constantly declining and terribly shrunken market. (From a 1935 trade magazine.)

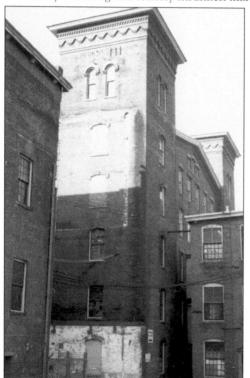

A MIX OF CONSTRUCTION STYLES. The mill buildings date from 1846 to 1918 and although the architectural styles vary, the complex is unified by the red brick that extends as far as the eye can see. The oldest buildings are quite plain, with shallow, pitched roofs. Fancy brick work over slightly arched windows is a sign of later construction. The 19 buildings of the mill complex are joined by a network of bridges— a challenge, since floor levels typically do not correspond from one building to the next. Bridges slant up and down, run at odd angles to the buildings they connect, and form a maze that is a test of skill to all.

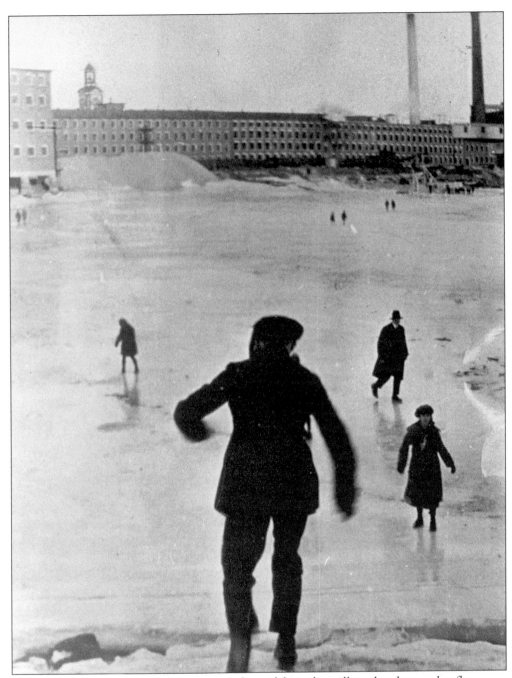

EMPTY MILLPOND. In 1916, the water was drained from the millpond and a wooden flume was constructed to provide waterpower to the mills. Draining the pond allowed for the construction of the foundation of No. 1 mill. It also allowed for children and adults to have the thrill of a lifetime by walking on the bottom of the millpond.

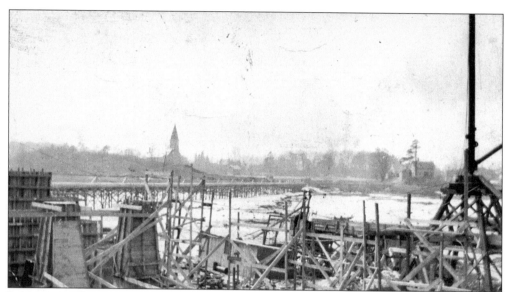

LAYING THE FOUNDATION. In preparation for the laying of the foundation for mill building No. 1 in 1916, the millpond was drained. A wooden flume was erected from the cove near the point at Front Street to the corner of mill Building No. 5, near the boiler room.

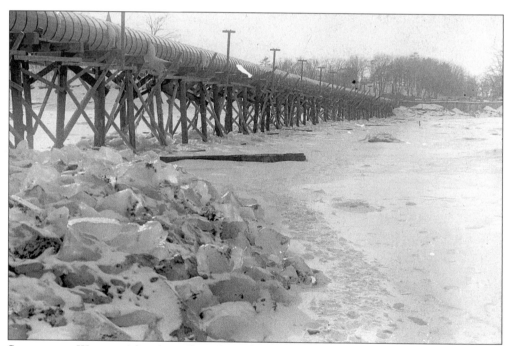

SUBSTITUTE WATER. After the millpond was drained so that the foundation for the new No. 1 mill building could be laid, a wooden flume was constructed to carry water from Sudbury Street to the mill.

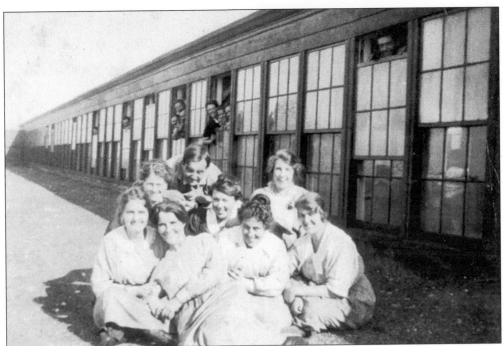

IMMIGRANT WORKERS. People moved to Maynard primarily to access job opportunities provided by the Maynard Mill. They included members of all races, religions, and nationalities, and they established many churches and insisted on quality schools.

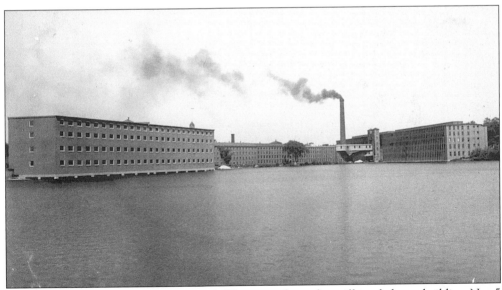

MILLPOND VIEW OF BUILDING NO. 5. This view from the millpond shows building No. 5 (right), shortly after it had been completed. Buildings No. 1 and No. 21 had not yet been constructed. The trains ran along the edge of the millpond. In the 1920s and 1930s, a big white arrow and the word Maynard painted on the roof of Building No. 5 were used as visual navigation for planes flying into Logan airport in Boston.

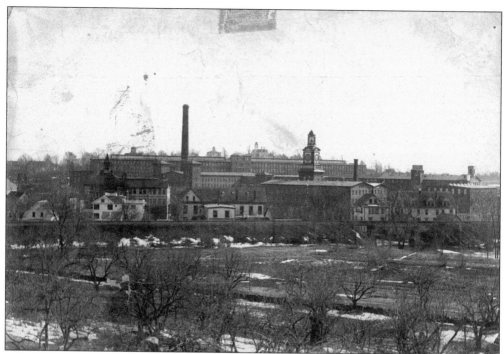

EARLY 1900 VIEW. The railroad embankment and bridge in the center of this photograph were completely removed in 1980 as part of the revitalization of the downtown area. Visible in the far distance behind No. 5 mill are, from left to right, the tower on the home of Lorenzo Maynard, the tank house for the mills, and the upper part of Amory Maynard's mansion.

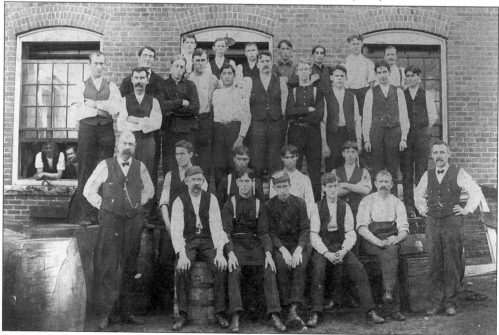

DRY FINISHING DEPARTMENT. This photograph shows members of the dry finishing department at the American Woolen Mills.

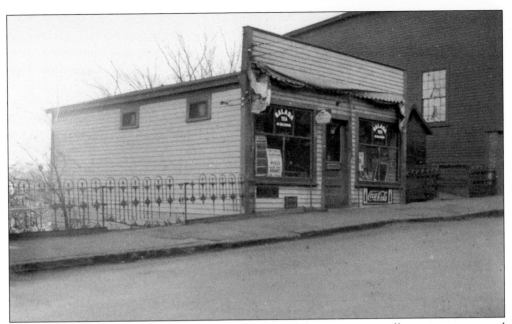

GROCERY AND SODA FOUNTAIN. This one-story, wood-frame store on mill property was rented for $75 per year in 1931. Mildred Crowe was the store owner. The structure to the right was one of the original mill buildings.

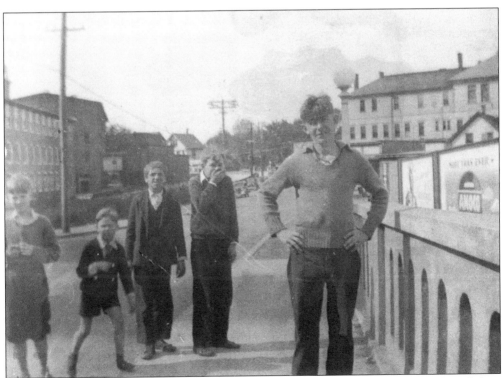

WALNUT STREET BRIDGE. Standing on the Walnut Street bridge in 1932 are, from left to right: unidentified, Roy Dean, Johnny ?, Victor Kizik, and Richard Sherman.

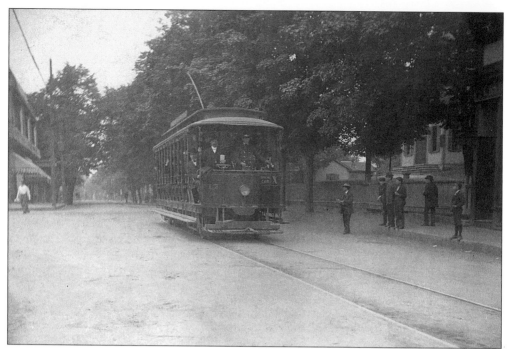

Special Trolley for the Overseers. This photograph, taken in front of the Congregational church on Main Street, shows the Concord, Maynard & Hudson Street Railway electric car with overseers of the American Woolen Mills about to leave for an outing in early 1900s.

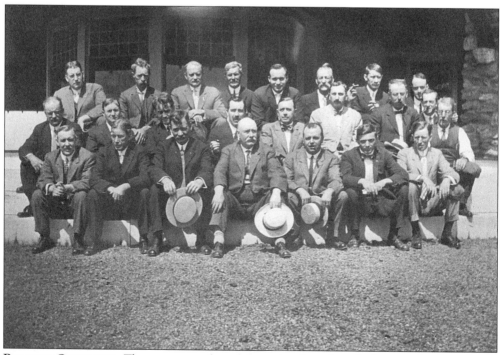

Relaxed Overseers. The overseers relax while posing for a formal photograph taken during an outing in Springfield.

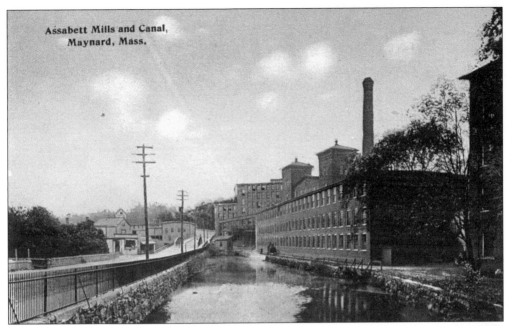

TRANQUIL ASSABET. The Assabet River flows smoothly and quietly past the Assabet Mills with enough power to operate all the mill's machines. The paper mill dam that was downstream from this point was one of the factors that contributed to the river's tranquility.

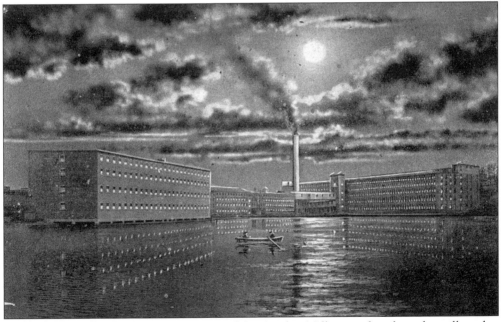

MOONLIGHT OVER THE MILLS. This view of the Assabet Mills was taken from the millpond at night, under a full moon and dramatic clouds.

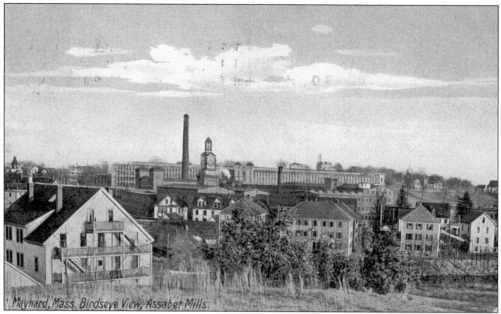

BIRD'S-EYE VIEW. This view from Summer Hill shows the mill's tenements on Florida Road with the mill in the background.

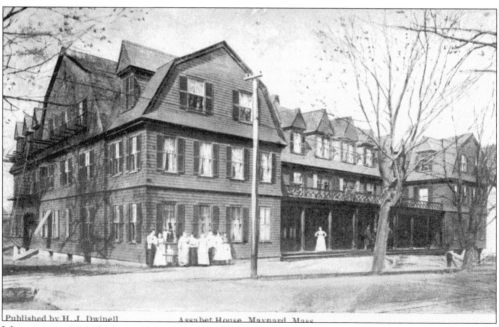

MIDDLESEX AND ASSABET HOUSE. This house was built as a rooming house with 39 rooms, 4 tubs, and 12 toilets. Each room rented for $25 a month. The building was owned by the mill, and most furniture belonged to the mill. Currently the site of the Maynard Post Office, the building was used as the Maynard Town Hall until the present town hall was built.

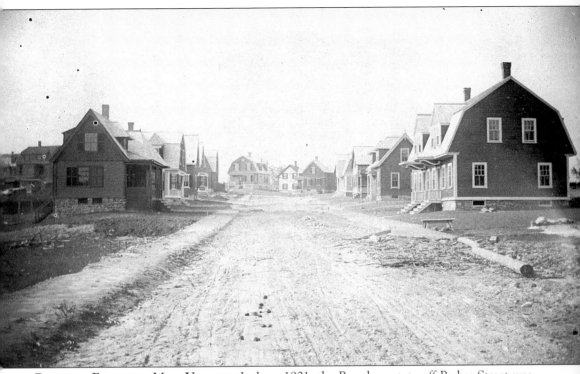

RISE AND FALL OF A MILL VILLAGE. In June 1901, the Reardon estate off Parker Street was purchased to build 60 tenements. Also in 1901, a large boardinghouse with 80 rooms was built on Main Street, and an old mill barn was torn down to make room for it. This was later known as the Middlesex and Assabet House. In 1902, the Mahoney estate off Waltham Street was purchased and staked out for tenements. In all, 160 were erected. Other boardinghouses, the Minto House and the West End House, were erected near the Central House on upper Main Street. Also, five new blocks were built, two on Sudbury Court and three on company property near the paper mill dam. In 1934, the American Woolen Company became solely a manufacturing enterprise by selling at public auction all its property except the mill buildings, because ownership of mill houses, once a necessity, was no longer economically justified. Most of the houses were purchased by the tenants. The Town of Maynard purchased the old Middlesex and Assabet boardinghouse on Main Street for a town hall. This was sold in 1962 and is now the site of the local post office.

150 DWELLINGS

101 Cottages, 49 Two Family Dwellings
12 Parcels Unimproved Land

At Public Auction to the Highest Bidder

FORMERLY PERTAINING TO THE

Assabet Mills

LOCATED IN THE TOWN OF

Maynard, Mass.

27 Waltham Street

26 Arthur Street

75% of the Purchase Price can Remain on Mortgage at 6%

ALL SALES ON THE PREMISES

Friday and Saturday, August 17 and 18, 1934

MILL VILLAGE FOR SALE. In August 1934, the American Woolen Company sold off the property used to house mill employees at a public auction. Most of the dwellings were purchased by the tenants who were living in them.

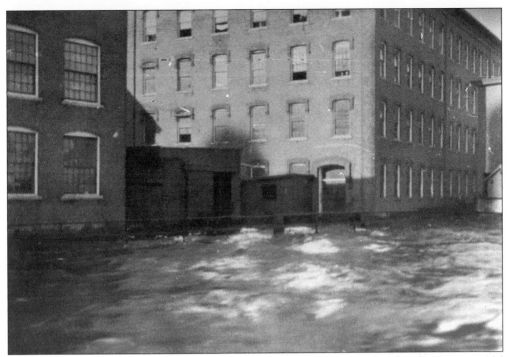

RAGING ASSABET RIVER. Building No. 11 is completely surrounded by the Spring 1936 floodwaters of the Assabet River.

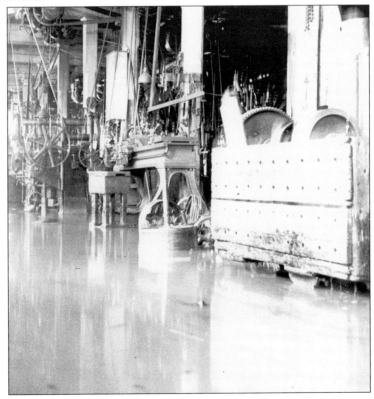

WATER IN THE MILL. During the flood of the Assabet River on March 13, 1936, the river rose high enough to spill over its banks and to include the Walnut Street machine shop in mill Building No. 11 as part of the river.

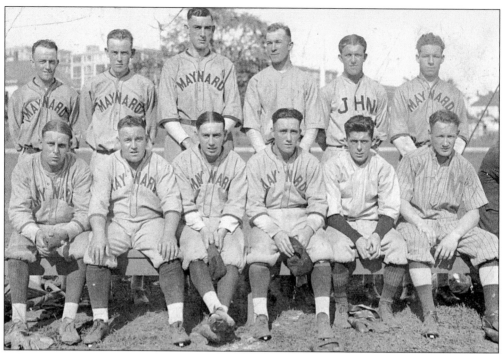

ASSABET MILLS BASEBALL TEAM. The Assabet Mills baseball team was the champion team in 1924, beating Washington Mills in the final game. Assabet team members, from left to right, are as follows: (front row) G. Sowles, outfielder; J. White, manager; F. O'Brien, second base; W. Johnston, short stop; H. Lyons, pitcher; and J. Moynihan, outfielder; (back row) H. Morgan, catcher; R. Marsden, third base; T. Marsden, first base; W. Morrill, pitcher; M. Vodoklys, outfielder; and W. Cates, outfielder.

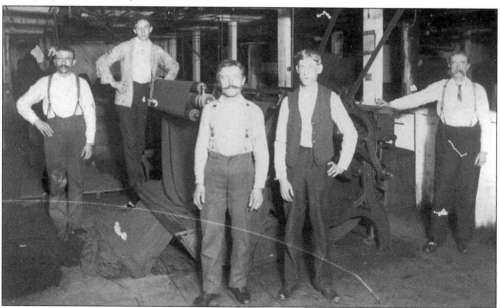

DRY FINISHING ROOM. This 1901 photograph shows members of the dry finishing crew at the Assabet Mills.

BEEHIVE MONEY SAFE. This large floor safe was installed in the main office building in the Assabet Mills. (Boothroyd.)

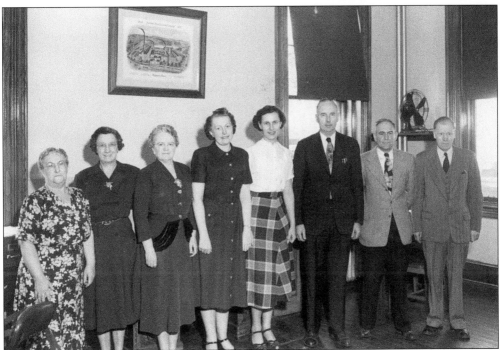

GENERAL OFFICE STAFF, 1951. Members of the general office staff of the Assabet Mills are, from left to right: Eva Frye, Agnes Mahoney, Eva Tucker, Jean Haynes, Ann Lawrynowicz, Geginal Jones, office manager Merton Merrick, and resident manager Peter Stalker.

FOR SALE

ASSABET MILLS

Property of American Woolen Company,
located at Maynard, Massachusetts

The Real Estate, consisting of various plots of land, numerous buildings, Power Plant, Water Rights and Privileges, as well as certain machinery on an inventory list on file at the Mill, is to be sold.

The Plant may be inspected on any business day, beginning Monday, November 6, 1950, between the hours of 8 A.M. and 4 P.M.

Arrangements for inspection can be made with Mr. Harold Goodwin, Cashier of the Plant. (Telephone Maynard 37).

Item 1. All Land, Buildings (exclusive of Power Plant), Water Rights and Privileges, are to be sold as one parcel. Floor space approximately 1,200,000 square feet.

Item 2. Power Plant is to be sold as one parcel and is subject to a separate bid.

Item 3. The machinery is to be sold as one parcel and is subject to a separate bid.

Bids will be received until November 20, 1950, and should be submitted and addressed to

President, AMERICAN WOOLEN COMPANY
225 Fourth Avenue, New York 3, New York

The Company reserves the right to reject any or all bids.

MILL FOR SALE. This advertisement was placed in the newspaper announcing that bids were to be accepted for the sale of the Assabet Mills on November 6, 1950. When business was good at the mills, the town flourished. However, there were many lean periods when the mills had to deal with panics, strikes, and shutdowns. With the closing of the Assabet Mills, the one-industry community of Maynard was without the mill payroll by which it had long depended. A local group was organized to negotiate with the American Woolen Company for the purchase of the mill property, but the owners rejected all bids and said they might reopen. In July 1953, ten enterprising Worcester businessmen formed the Maynard Industries, Incorporated, and purchased the huge mill property for $200,000.

56

Three

WOOLEN
MANUFACTURING
PROCESS

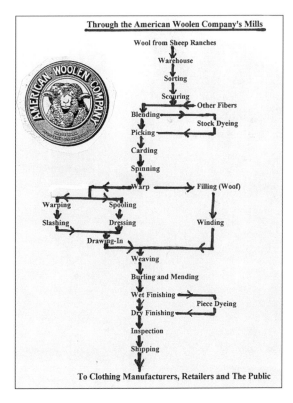

Through the American Woolen Company's Mills

Wool from Sheep Ranches

Warehouse

Sorting

Scouring

Blending — Other Fibers

Stock Dyeing

Picking

Carding

Spinning

Warp — Filling (Woof)

Warping Spooling

Slashing Dressing Winding

Drawing-In

Weaving

Burling and Mending

Wet Finishing

Piece Dyeing

Dry Finishing

Inspection

Shipping

To Clothing Manufacturers, Retailers and The Public

PRODUCTION MAP. This chart shows all the steps that wool goes through after being received from the sheep ranches until exiting as finished wool cloth ready for clothing manufacturers.

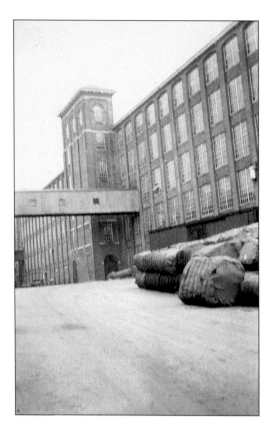

WAREHOUSING. This picture shows raw wool stacked outside the No. 1 mill building. Some 70% or more of the raw wool used by the mill came from foreign sources, since U.S. wool production was low. These sources included South America, Australia, and South Africa, which, along with the United States, are the four major wool-producing areas of the world.

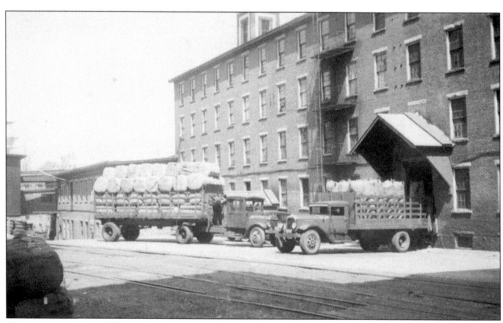

UNLOADING RAW WOOL. Trucks unload their shipment of raw wool onto the loading dock at the No. 3 mill building.

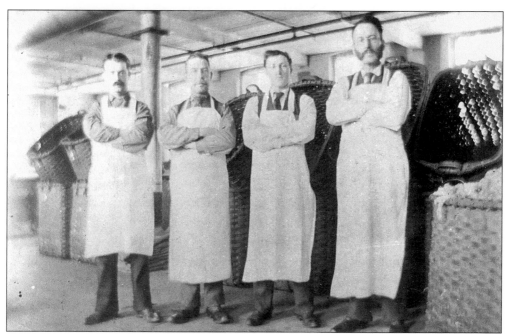

WOOL SORTERS. Wools from each area of the world have their own special characteristics. Fibers also vary from section to section in these areas and from year to year, from sheep to sheep, and even from one part of the fleece to another. Arriving at the mill from the warehouse, the bags and bales are broken open and the fleeces are pulled apart by skilled sorters, who separate and sort the fibers according to type, grade, and length.

WOOL SCOURING. Coming by gravity from an upper floor, the raw wool is fed into the scouring bath. As it enters, the wool is about one-half usable fiber and one-half fat, grease, dirt, burrs, and other foreign matter, which must be removed. The rows of spikes reach out to submerge the wool and drag it through the block-long system of cleansing vats. When thoroughly scoured, the wool goes through a dryer from which it emerges white, fluffy, and dry. Coming over a heated, perforated conveyor, the wool drops into a suction feed where huge blowers force it through pipes to the next operation.

FRED LLOYD, DYER. The wool in the woolen mills could be dyed either as loose wool (dyed in the wool), or as yarn (skein dyeing) or as cloth (piece dyeing). Dyers with a high level of skill, such as Fred Lloyd, were found mainly among recent immigrants.

H.C. TEMPLETON. Shown here in his office in 1936 is H.C. Templeton, the American Woolen Company's resident manager of the Maynard mill complex.

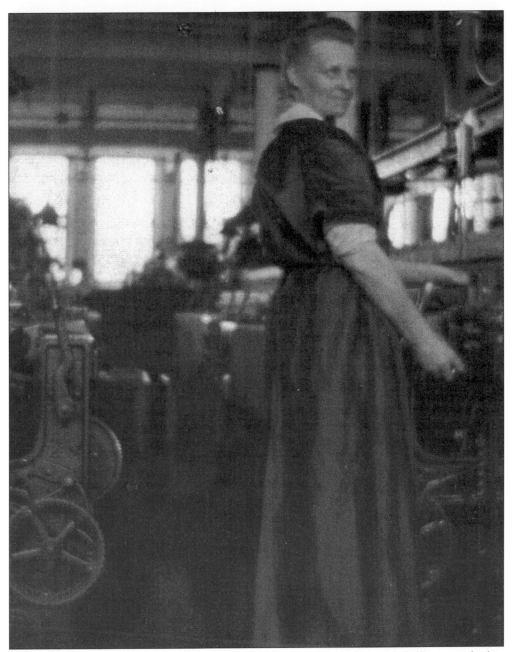

HANNAH SARVELA, COMBER. Before coming to the comb, the card balls get a further straightening as fibers from four of them are gilled and combined into one four-section roll. After being brought to the combing room, 18 of these rolls are mounted on the rotating outside rim of the combing machine. Continuing the straightening process, the comb's drawing-off rolls drag the fibers through tiny pins as they feed toward the center of the machine, where the long fibers for worsteds are separated from the short fibers. Long fibers from all 18 rolls are brought together to form a single loose, ropy strand, which feeds into the tall can. The short fibers, or noils, which are pulled away from the long fibers, feed out through the bottom of the comb, ready to go to the woolen mills. (Sarvela.)

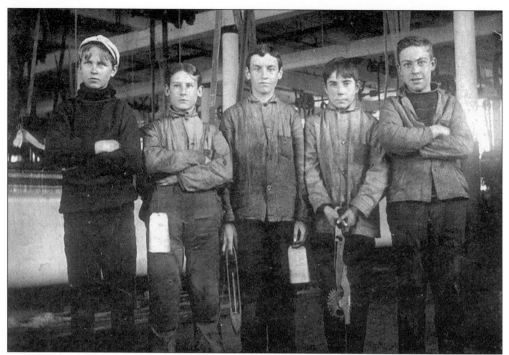

BLENDING, A BOY'S JOB. In the woolen manufacturing system, scoured wool and other wool fibers are blended before the carding operation. As of 1891, one-eighth of the workers were less than 16 years old and made 5.5¢ per hour.

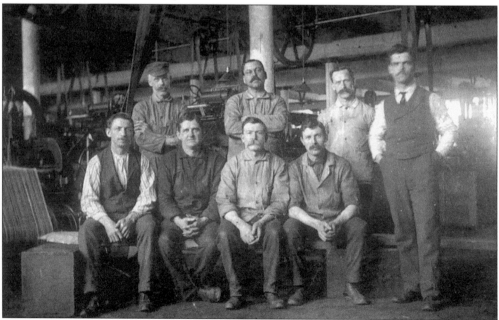

PICKING, A MAN'S JOB. In this operation, the assortment of wool fibers is shredded between powerful, heavy-toothed cylinders that mesh with each other to mix the fibers while grinding out and removing most of the foreign matter still sticking to the wool. The average male working in the mill made 16.5¢ per hour.

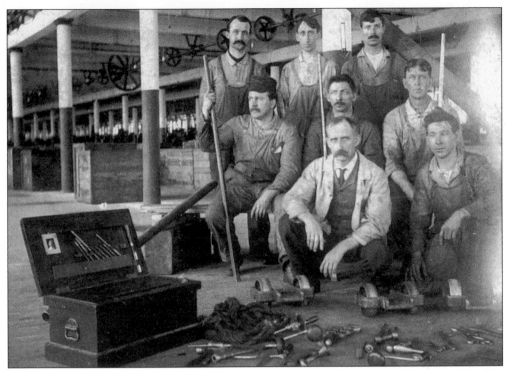

SIZING. After the wool has been spun into threads, but before it goes to the loom, it is sized to give it greater strength. The sizing is a glue-like substance that coats the thread and reduces breakage in the loom. This picture shows a team of pipe fitters who are part of the mill's general maintenance team.

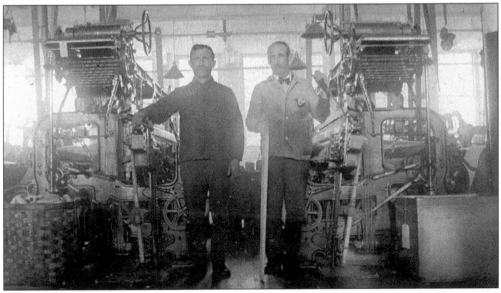

SLASHING. After sizing, the yarn passes through a slasher where a set of rods splits up the threads and prevents them from sticking together. After slashing, the threads are wound on the warp beam and made ready for the loom. This photograph shows a good view of the weave room.

CARDING, STEP 1. In the woolen system, the wool fibers are straightened and smoothed as they go through one card cylinder after another. The web of fiber coming off the cylinder is gathered into a flat strand and run up over the conveyor to the next card cylinder where it is spread out evenly across the feed, which projects it into more series of tiny-toothed revolving cylinders. In this process the fibers become more thoroughly mixed together until the web is of uniform thickness across the cylinders. This photograph shows a section of a back winder.

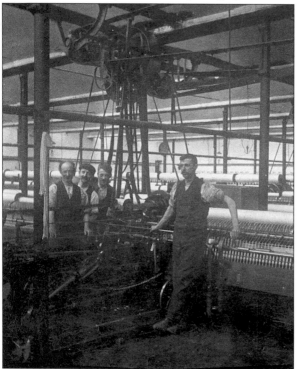

CARDING, STEP 2. After carding, the wide, thin web of wool fiber is picked up and divided into strips by the tapes on a small cylinder. These fragile bands of fiber then feed off tapes and through broad rub aprons, which rub crosswise against each other as they roll the fibers into roping. The roping on the card spools is now ready for spinning into woolen yarn. This photograph shows the spinning room.

MULE SPINNING. In mule spinning, 300 to 400 ends of roping are fed from the card spools mounted on a stationary frame to the bobbins revolving on spindles on the moving carriage. As the carriage moves away from the frame, the roping starts to unwind and then a braking device stops the unreeling while the carriage continues its travel. This drafts, or elongates, the strand of roping while the bobbins whirl at high speed as they spin the yarn. The carriage then reverses its direction and as it wheels back toward the frame, the bobbins wind up the spun yarn. The cycle is repeated until the bobbins are full. This photograph shows a mule spinner machine.

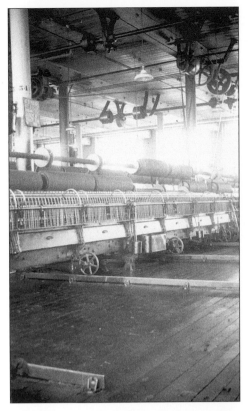

SPINNING ROOM EMPLOYEES. This photograph was taken in the mill's spinning room in 1905.

65

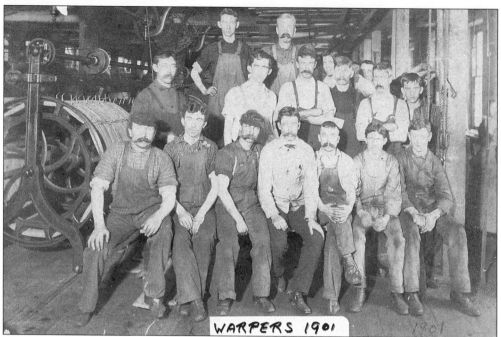

WARPERS 1901

SPINNING. Here, the roving becomes worsted yarn as it goes from the spools at the top of the spinning frames to the smaller spools, or bobbins, below. In this operation, the roving is drawn again and then simultaneously twisted and wound up by the bobbins which whirl at tremendous speeds. The 1,000 yards of roving now become as much as 8,000 yards of yarn. In the next operation, twisting, two or more strands of yarn will be twisted together to form heavier threads. This 1901 photograph shows the mill's warpers.

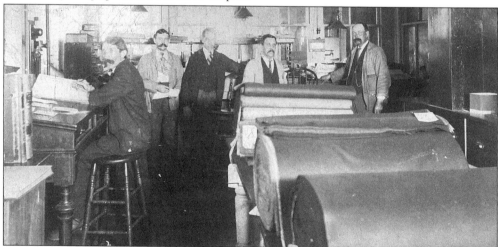

WARPING SCHEDULING DEPARTMENT. To make up the warp of a 58-inch to 60-inch finished width fabric, between 4,000 and 7,000 separate threads may be needed, each of which is far longer than the thread on any one bobbin. One method of gathering in and piecing together all these threads, or ends, as they are called, is that shown in this picture, high-speed warping. In a previous operation, threads from thousands of bobbins were wound to the cones mounted on the racks, or magazine creels. Here hundreds of these longer threads feed side by side onto the warper beam, the giant spool in the foreground, at the rate of 400 yards per minute.

66

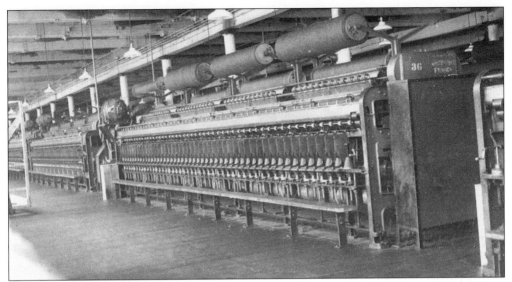

FRAME SPINNING. The roping from a number of card spools is drawn, spun, and wound onto bobbins, which whirl at 5,000 to 6,000 revolutions per minute. The twist given the strands locks the individual fibers together, building the strength needed for the threads of the fabric. This photograph shows a frame spinner at the mill.

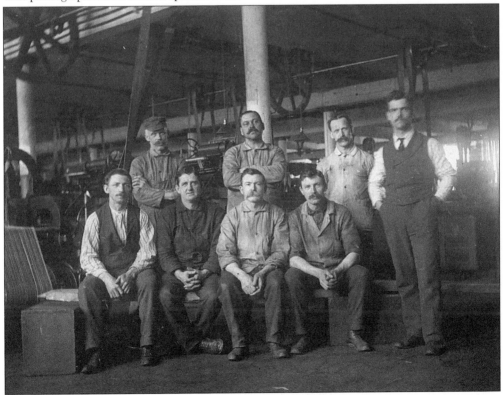

LOOM FIXERS. This photograph shows the loom fixers in the early 1900s. They are, from left to right, as follows: (front row) Wilbur Hamlin, John Brophy, Harry Sullivan, and David Sharpe; (back row) William Whitehead, George Howes, Harry Brailey, and Albert Hamlin.

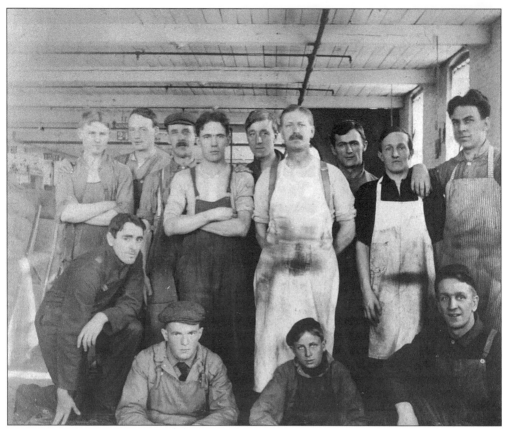

DRESSING. The warp yarns from the dresser spools are combined and laid side by side as they are wound in sections on the dressing reel. In a later operation, the threads from 5 to 20 sections of this reel will be further combined when they are wound to the loom beam that will furnish the warp threads for the fabric. This photograph shows some of the workers in the dressing area of the mill.

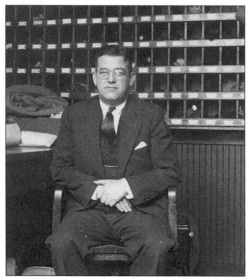

ROY NELSON. Roy Nelson, shown here in his office in 1935, was the superintendent in charge of all the mill buildings at that time.

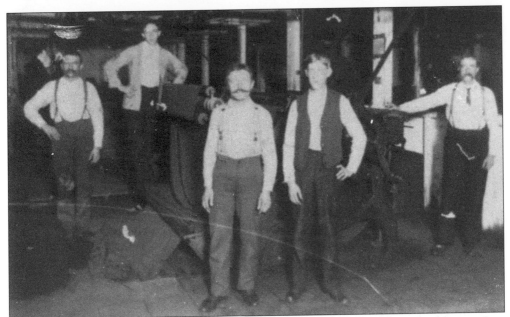

SLASHING. Coming from 16 warper beams, more than 6,000 separate ends are brought together. As they pass under the rollers in the machine they receive a coating of a glue-like substance called sizing to strengthen them for the stresses of weaving, and then they feed through a heated chamber where the sizing is dried. They emerge at the far end of the slasher to be separated from each other by rows of pins, which also space the threads at proper intervals as they wind onto the loom beam or warp beam. This photograph shows the operators of the slashing machine.

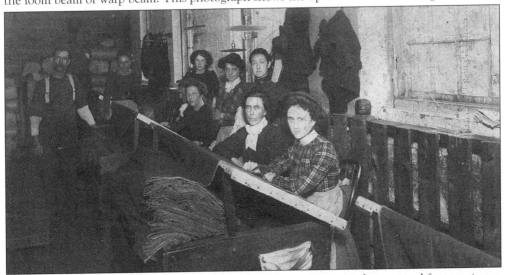

DRAWING IN. The thousands of ends on the loom beam now must be arranged for weaving so that they will duplicate the designer's pattern of warp threads. The operator pulls the ends of thread, one by one, through wire loops, or heddles, which hang from the set of frames called harnesses. When finished, the operator will have drawn each end through a different heddle in one or another of the 14 harnesses. After they are fitted to the loom, the harnesses will be raised and lowered in combinations of warp threads which will make the desired weave of the fabric. This 1905 photograph shows specking room employees.

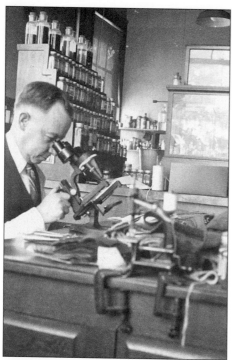

TOP DYEING. Strands of finished top are wound from the large, loose top balls onto special perforated cylinders and then are covered with a protective outside layer of cheesecloth. When the operator finishes putting the lids on the cylinders, they will be tightened down, and then the dye solution will be forced up from the bottom through each cylinder, permeating the fibers with the desired color as it surges through the cylinders under pressure. This photograph is of mill chemist G. Stuart.

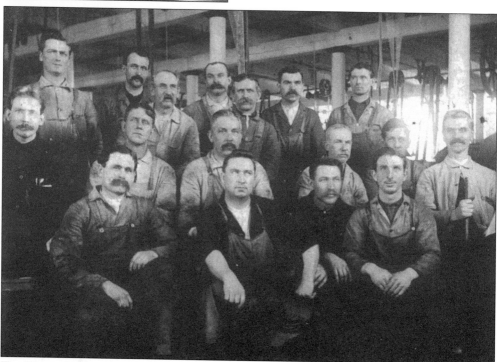

THE GANG IS READY TO WORK. At quarter of the hour and then again at five minutes of the hour, the whistle gave one blast. Everybody was supposed to be inside the gate when that second whistle blew. Then, at one minute of the hour, a bell rang just once, a quick ring. It was referred to it as "the tick" because everybody was supposed to start work at that time.

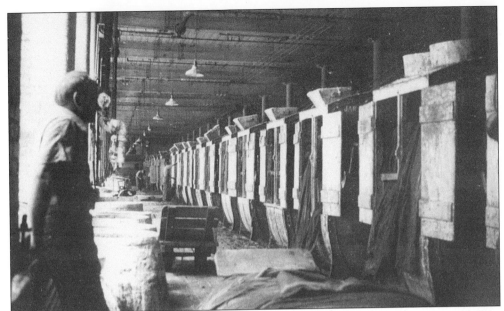

FULLING MILL. This step shrinks and thickens the wool cloth by moistening it and then heading and pressing the cloth. Shown in the photograph is one string of fulling machines.

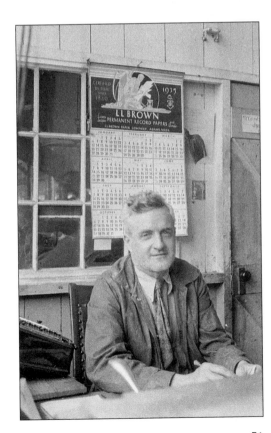

FRANK BRAYDEN. Frank Brayden was the boss of the fulling department. The fulling department contained 70 fulling machines.

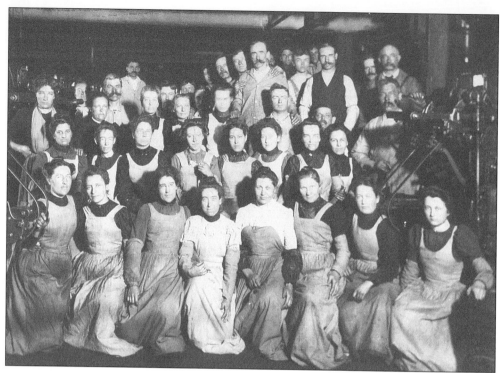

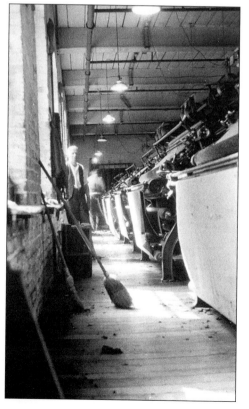

SIZING AND SLASHING. After the wool has been spun into threads but before it goes to the loom, it is sized to give it greater strength. The sizing is a glue-like substance that coats the thread and reduces breakage in the loom. After sizing, the yarn passes through a slasher where a set of rods splits up the threads and prevents them from sticking together. This separation is designed to further smooth and even the winding on the warp beam. This 1901 photograph shows the operators in the weave room.

WEAVING. This operation is the manufacturing climax, for it is here that the thousands of yards of individual threads are brought together in the loom and woven into fabric. In previous operations, the up and down threads, or ends, that will form the warp of the fabric have been wound onto the huge loom beam and the cross threads that make up the filling of the cloth have been wound on small automatic bobbins for use in the shuttle. This photograph shows the shear room in the mill used for trimming woven cloth.

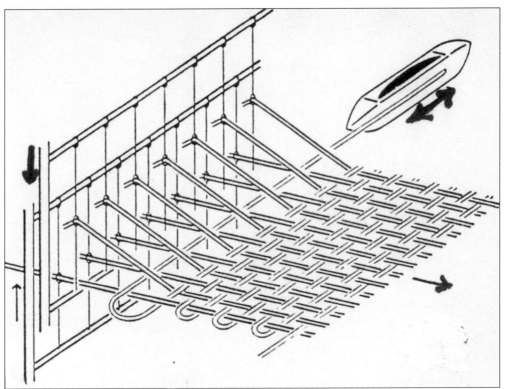

THE SHUTTLE. The shuttle, a double-pointed device that carries the automatic bobbin, trails a taut thread and packs it tightly against the woven part of the fabric at the instant the shuttle reaches either end of its travel. Also in that split second, different harnesses are raised and lowered in a predetermined pattern so that on its return trip, the shuttle passes over and under different groups of warp threads. It is the combination of the filling threads passing over or under various sets of warp threads that makes the desired weave.

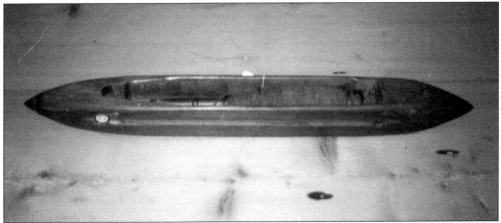

SHUTTLE WITH BOBBIN. This shuttle contains a bobbin of yarn that was used in the Assabet Mills during World War I. As a shuttle slams back and forth as fast as 134 times a minute, bobbins carrying different colors of thread are automatically selected at the left end of the loom. At the right end, empty bobbins of each color are automatically replaced by full ones of the same color. All this is done without any interruption of the loom's great speed. (Boothroyd.)

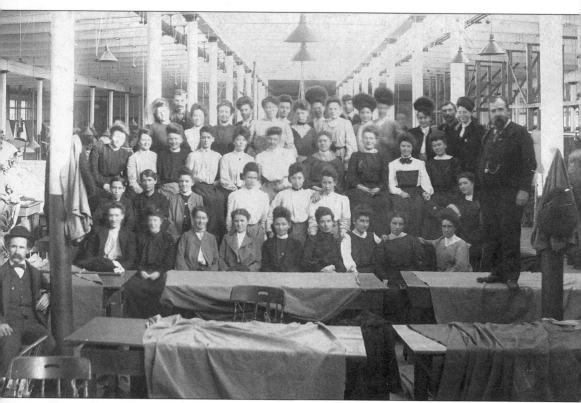

Burling and Mending. In this operation, slight imperfections in the cloth are corrected by highly skilled operators with keen eyes and nimble fingers. Burling consists of pulling knots in the yarn to the back of the fabric, where they will be sheared off uniformly in a later step. Mending is the weaving in by hand of threads to replace broken and missing threads. As these have become almost lost arts, the American Woolen Company conducts its own on-the-job training program for burlers and menders. Shown here are, from left to right, the following members of the sewing room: (first row) ? McAuslin, Sadie McGarry, Kate Sweeney, Nettie Binns, Inez Scully, Celia O'Toole, Lizzie Mahan, Mame Kelley, Nellie Mahen, and Margaret Keegan; (second row) Frank Moynihan, Connie Desmond, Mamie Callahan, Nellie Crotty, Margaret Lydon, Elizabeth Lobin, and Alice Payne; (third row) Joe McNulty, Nettie Henderson, Marjorie Hoar, Connie Coscadden, Minnie Comisky, Lena Resmussen, Gertie Randall, Cora Nelson, Mary Burns, and Kate McCarthy; (fourth row) Cody Reading, ? Primiano, Margaret Joyce, Annie Lynch, Esther Bowers, Lena Johnson, unidentified, Mattie Naylor, Lena Johnson, Martha Binns, Edith Fisher, Bertha Archer, Amy Worship, Lilla Moore, John Primiaus, Evie Collaten, boss ? Downs, and ? O'Connel.

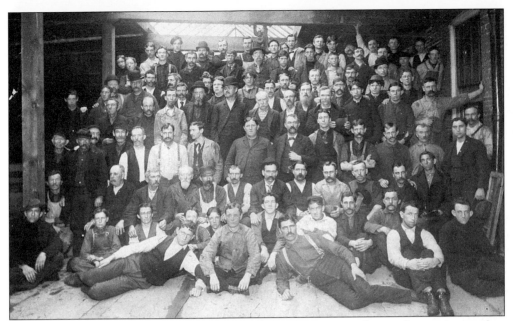

WET FINISHING. Of the many series of wet-finishing operations used to produce various surface finishes on the fabrics, washing and rinsing are common to all. Thousands of yards of fabric, sewn end to end, feed through a series of nine huge bowls that contain various cleaning and rinsing solutions. This 1901 photograph shows employees of the wet-finishing department.

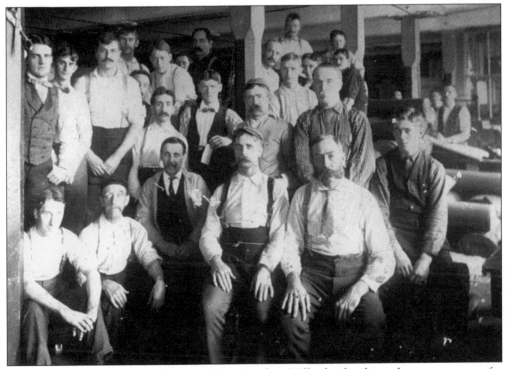

DRY-FINISHING CREW. Employees of the Assabet Mills dry-finishing department pose for a photograph.

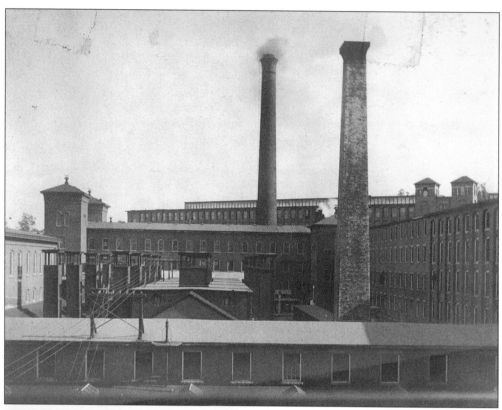

ASSABET MILLS, 1905. This view of the Assabet Mills was taken looking out over the roof of the dye house.

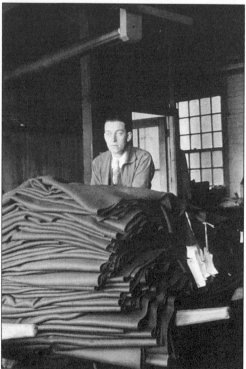

JOHN HEATON. John Heaton worked in the wet-finishing department of the mill.

PIECE DYEING. A set of lengths of undyed fabric is fed in and out of the steaming dye solution until it reaches the desired color. Any decorative stripes of non-wool fibers introduced into the weave will not take the dye as the wool fibers do and, thus, will come through the dyeing process in their original colors. Shown here is C. Dyson of the dry-finishing department.

DRY FINISHING. Fabrics are steamed, brushed, sheared, and pressed during this series of operations. The nap is raised by brushes and then is cut to a uniform height by the huge shear blade, which operates like a stationary lawn mower as the fabric is fed under it. After shearing, the fabric may go through two or three more finishing processes, including pressing, before it is ready for final inspection, or perching.

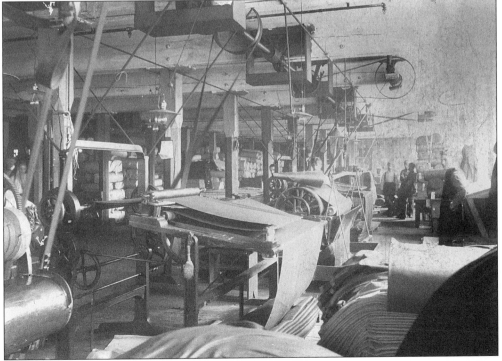

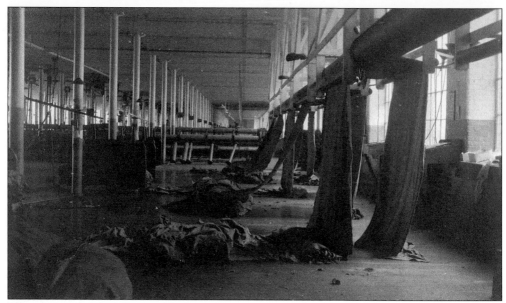

WEAVE ROOM. This photograph shows the mill's weave room in 1919.

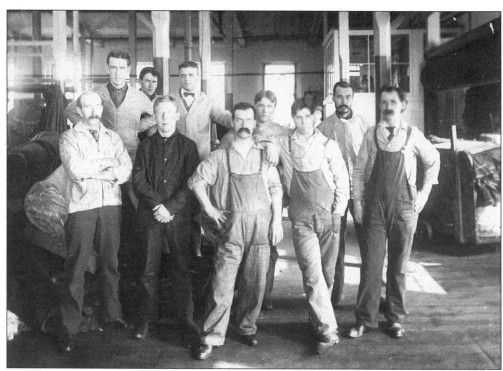

PERCHING WEAVE ROOM. The employees of the perching weave room in the mill are, from left to right: James Keller, Frank Johnson, Thomas Wright, Harry Brooklyn, William McAuslin, Hiram Parkin, August Moynihan, Herbert Whitehead, and ? Smith.

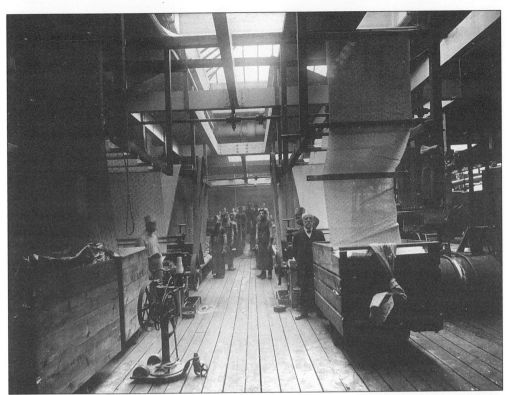

FINAL INSPECTION. Examining the fabrics as they are pulled over high racks, or perches, inspectors reject or pass the finished pieces according to rigid standards set for the particular grades of fabric. Next, the cloth goes to the shade room, where the resident manager of the mill examines each piece of finished goods.

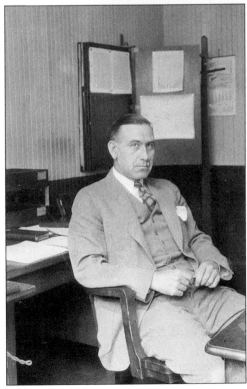

H. JOHNSON, PRODUCT MANAGER. All production at the Assabet Mills in 1935 was under the direction of H. Johnson, who is shown here in his office within the mill.

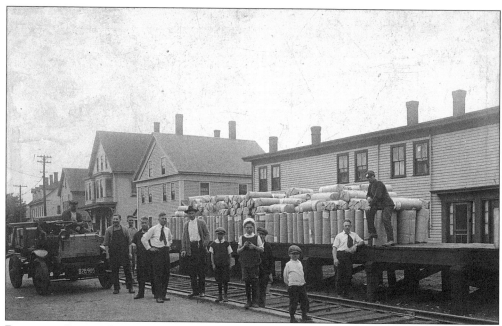

READY TO SHIP. After six weeks of processing, raw wool has become finished cloth, ready for shipping to fill the orders placed months earlier by the buyers for the clothing manufacturers and the jobbing trade. Shown here is a shipment of cloth in 1920. The mill workers were able to load 347 pieces of wrapped wool onto the train car in 5.5 minutes.

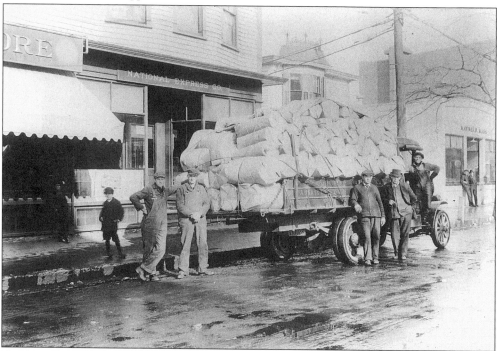

EXPRESS SHIPMENT. For delivery to locations nearby, the cloth was taken to the National Express Office. This 1916 photograph shows, from left to right, Arthur Jordan, Richard Parmenter, Joseph Fitzpatrick, Arley Lawrence, and William Nelson.

CUSTOMER LINEUP. Many clothing manufacturers buy the fabric made by the mills and make and sell products under their own brand name.

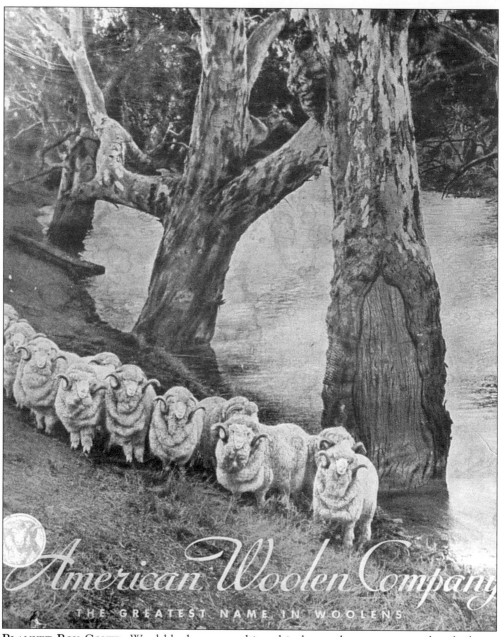

BLANKET BOX COVER. Wool blankets were shipped in boxes that were covered with this illustration. The color of the box was also the color of the blanket.

Four
MAYNARD INDUSTRIES

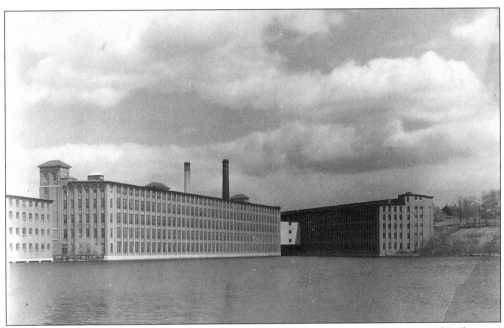

NEW BEGINNING. In 1953, ten Worcester businessmen, organized as the Maynard Industries, Inc., completed negotiations that had been in the works for three or four years and bought the American Woolen Company mills. Louis Penstein, president of the new company, began leasing space to tenants, some of whom were established firms, while others were just getting started. One of the new companies that found the low cost of Maynard Industries space appealing was Digital Equipment Corporation, which started operations in 8,680 square feet in the mill in 1957.

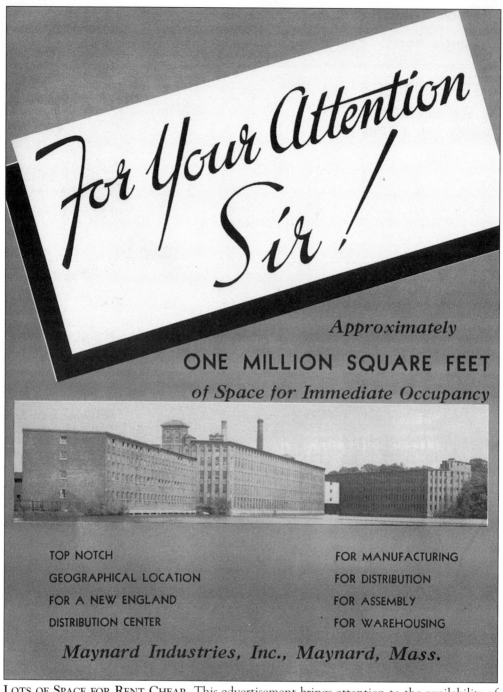

LOTS OF SPACE FOR RENT CHEAP. This advertisement brings attention to the availability of quality space for emerging industries to get started with plenty of room to grow.

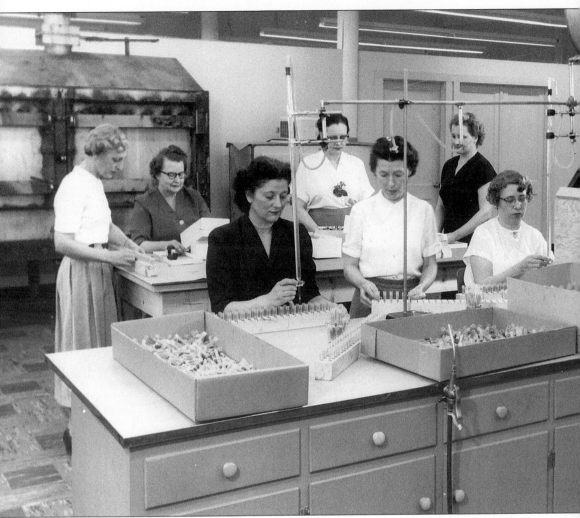

BRADLEY CONTAINER CORPORATION. In October 1953, a lease was negotiated with Maynard Industries, Inc., for two floors of manufacturing space, plus an enclosed truck loading space. Maynard Industries provided heat for the building and watchman service, as well as a parking lot across the street and access to millpond water for manufacturing purposes. The company was given an option to purchase after three years the entire five-story building it was occupying for $200,000. Pictured here are the first seven women to become regular employees of the factory division of the Bradley Container Corporation. They are, from left to right, Catherine DeGrappo, Ellen Barnes, Dalfina DeMambro, Margaret Piecewicz, Natalie Crowley, Virginia Szerzen, and Alice Hanson. (Flood.)

BEACON PUBLISHING COMPANY. The first company to move in following Maynard Industries' purchase of the Assabet Mills was the Beacon Publishing Company in the summer of 1953. Earle Tuttle of South Acton was the owner and publisher of the Beacon Publishing Company.

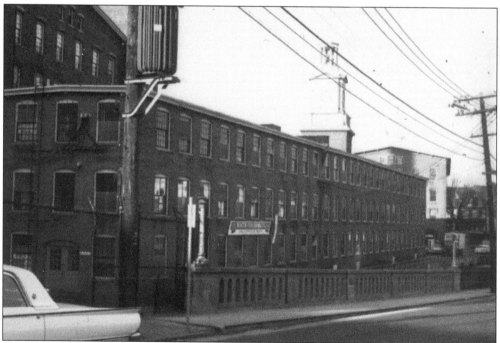

PUBLISHING BUILDING. The Beacon Publishing Company was housed in this mill building and originally provided offset and letter press services. The company later started publishing a newspaper, the *Beacon*, which changed its name in 1963 to the *Assabet Valley Beacon*.

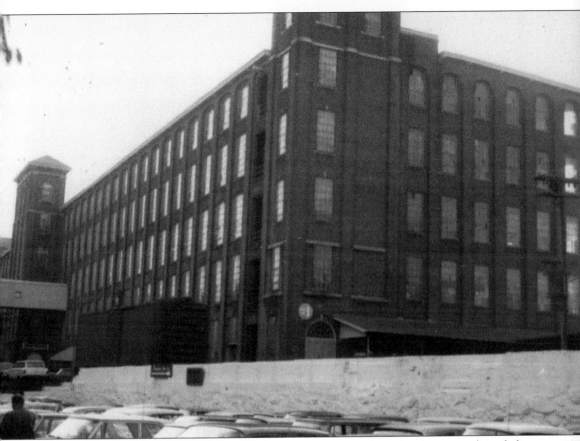

RAYTHEON COMPANY. In October 1955, the Raytheon Manufacturing Company leased the entire 65,000 square feet of space in this building. The space was used for development and engineering activities of a radar systems group attached to Raytheon Missile and Radar Division. The new addition in Maynard was part of the Waltham electronic firm's program of expansion, the latest of which included a new multi-million dollar engineering laboratory in nearby Wayland.

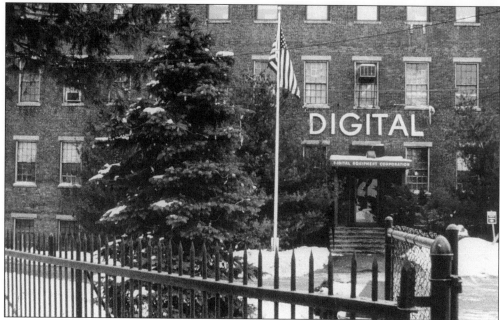

DIGITAL EQUIPMENT CORPORATION. On July 9, 1957, Ken Olsen and Harlan Anderson decided to rent the second floor of Building No. 12, which consisted of 8,680 square feet. They signed a three-year lease at a monthly rental of $300. At the time, the mill buildings were about 90% occupied. For the next 17 years, Digital grew and occupied more and more of the mill space as it became available. In June of 1974, Digital purchased the complex for $2.25 million.

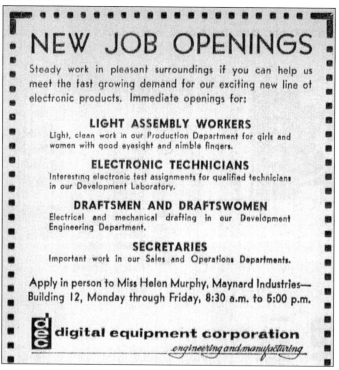

NEW JOB OPENINGS

Steady work in pleasant surroundings if you can help us meet the fast growing demand for our exciting new line of electronic products. Immediate openings for:

LIGHT ASSEMBLY WORKERS
Light, clean work in our Production Department for girls and women with good eyesight and nimble fingers.

ELECTRONIC TECHNICIANS
Interesting electronic test assignments for qualified technicians in our Development Laboratory.

DRAFTSMEN AND DRAFTSWOMEN
Electrical and mechanical drafting in our Development Engineering Department.

SECRETARIES
Important work in our Sales and Operations Departments.

Apply in person to Miss Helen Murphy, Maynard Industries— Building 12, Monday through Friday, 8:30 a.m. to 5:00 p.m.

d|e|c digital equipment corporation
engineering and manufacturing

DIGITAL NEEDS PEOPLE. An advertisement in the local newspaper identified areas where the growing Digital Equipment Corporation needed additional employees.

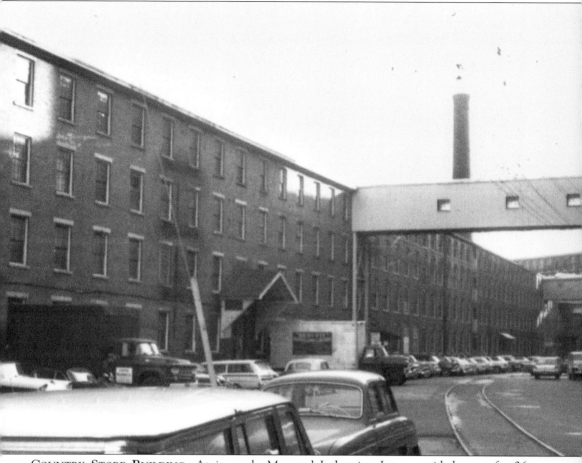

COUNTRY STORE BUILDING. At its peak, Maynard Industries, Inc., provided space for 26 industries and stores as follows:

American Dynamics
Beacon Publishing (Bldg #6)
Bonny Mfg. Corp.(Bldg #3)
Bradley-Sun (Bldg #5)
Brand-Rex Div. (Bldg #11)
Capital Molding Corp. (Bldg #10)
Chaffee Millwork (Bldg #3)
Condit (Bldg #3)
Country Store (Bldg #3)
Dennison Mfg. Co. (Bldg #1)
Digital Equipment (Bldg #12)
Electronautics Corp. (Bldg #11)
Hudson Bros. Mfg. Inc. (Bldg #3)

Imagination Co. (Bldg #3)
Information International (Bldg #6)
Lewis-Shepard (Bldg #3)
Maynard Pattern Co. (Bldg #6)
N.E. Woodworking (Bldg #6)
No-Lik Products (Bldg #6)
Radiation Eng. Lab
Raytheon Mfg. Co. (Bldg #5)
Scott Inc. (Bldg #6)
Spectran Electronics (Bldg #11)
Thayer Mfg. Co. (Bldg #1)
Universal Toy & Container (Bldg #7)
Valcon Associates (Bldg #3)

MAYNARD INDUSTRIES OFFICE SPACE. Maynard Industries provided each of its lessees with watchman service, heat, a sprinkler system, snow removal, elevator maintenance, a sound structure, and payment of real estate taxes. The lessee was obligated to pay for any insurance and improvements to the basic building—including wiring, lighting, and office finish, and leaving the premises in at least as good shape as when initially rented.

FOR LEASE
INDUSTRIAL SPACE
MAYNARD, MASS.
12,000 sq. ft. on One Floor
Good for mfg. & Storage
HEAT - SPRINKLERED
With Watchman Service
NATURAL LIGHT
New Office Space - Light
& Power Fixtures Included
Available Dec. 1st
For further information call

a. I. Rome

INDUSTRIAL SPACE AVAILABLE. An advertisement placed in the local newspaper indicated that 12,000 square feet of the old mill complex was available to lease suitable for manufacturing or storage.

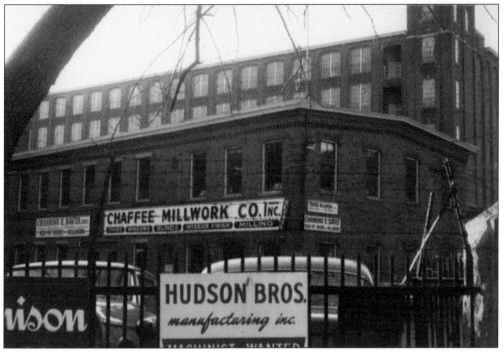

CHAFFEE MILLWORK COMPANY. The Chaffee Millwork Company, located in Building No. 3, manufactured window units, all types of doors, blinds and shutters, disappearing stairways, and kitchen and corner cabinets, and provided custom milling.

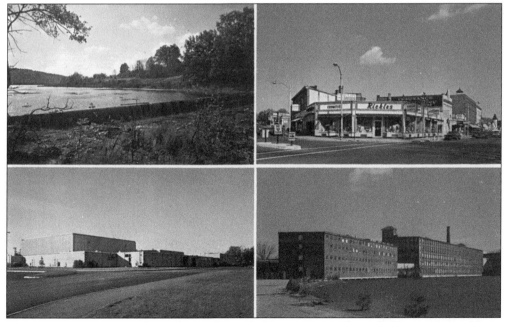

THE MILL TOWN. With the influx of diversified businesses in the mill, Maynard was able to build a new high school and to maintain a strong business base in the downtown area. Shown here are four local views of Maynard: the Ben Smith Dam, upper left; the business district, upper right; Maynard High School, lower left; and the millpond, lower right.

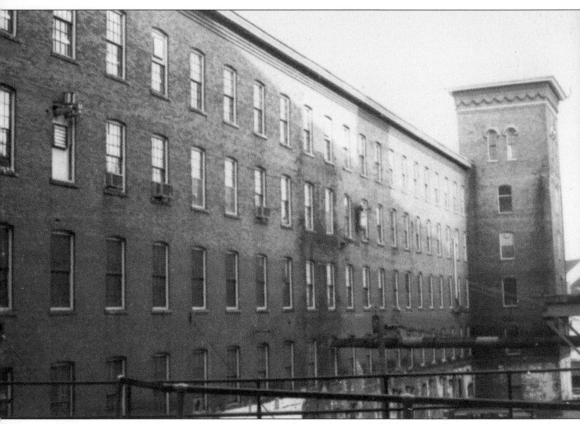

MIGHTY MAYNARD. Besides the mill buildings made available to industries by Maynard Industries, the town of Maynard also provided the following incentives for industrial development: a good supply of skilled labor; a secondary labor source from the neighboring towns of Acton, Stow, and Sudbury; good transportation, with railroad tracks right up to a company's loading dock and main highways nearby; neighboring support industries; proximity to markets; and a stable community.

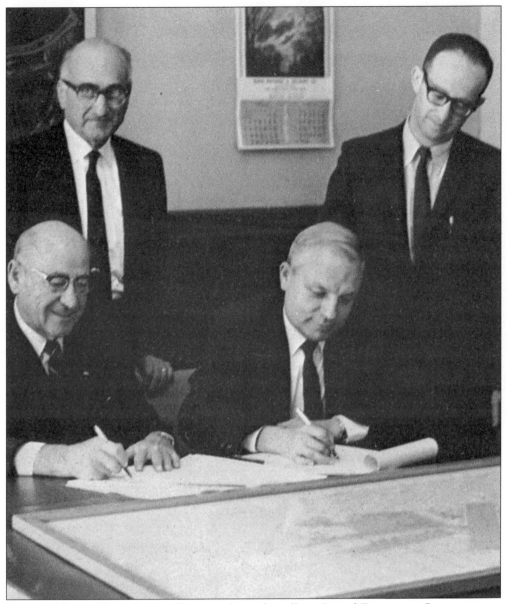

DIGITAL NEEDS MORE SPACE. Signing a lease that allows Digital Equipment Corporation to occupy two additional buildings in Maynard Industries mill buildings are, from left to right, (sitting) Lewis Pemstein, president of Maynard Industries, and Harry Mann, Digital vice-president of finance; (standing) Hyman Berwick, director of Maynard Industries, and Ed Schwartz, Digital's corporation counsel.

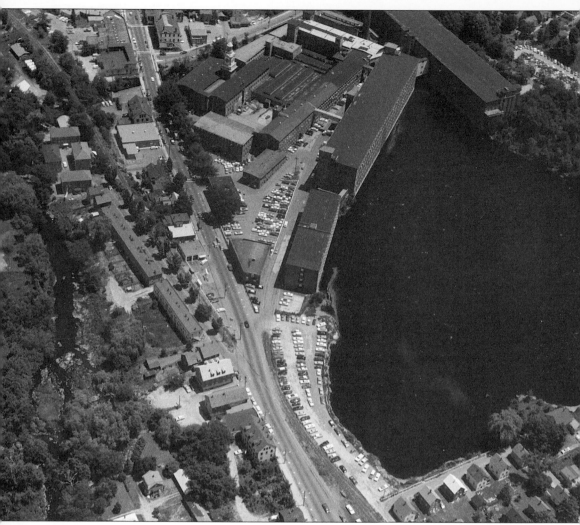

MAYNARD INDUSTRIES, AERIAL VIEW. This aerial view shows the mill buildings clustered around the millpond. The activities of the mill tenants included manufacturing, distribution, storage, publishing, retailing, woodworking, sign painting, pattern making, and working in the machine shops. Products they manufactured included dental supplies, paper products, upholstery, extruded plastic tubes, bottles and containers, corrugated boxes, burlap bags, injection molded plastics, systems modules and computers, radar systems, baby furniture, jewelry cases, woolen blankets, Orlon blankets, pressure-sensitive tapes and labels, reinforced plastics, and food tray carriers for the airlines. (Lancaster.)

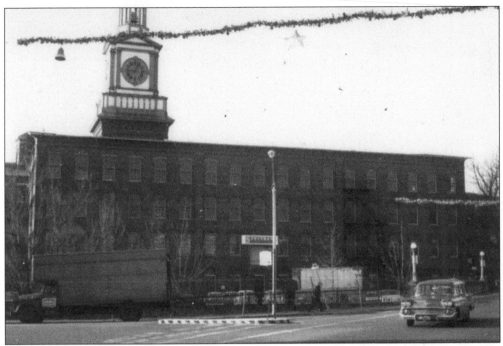

SPECTRAN ELECTRONICS. Spectran Electronics was located in Building No. 11.

BRADLEY CONTAINER NEEDS HELP. An advertisement in the local newspaper offered good wages and benefits to skilled electricians, carpenters, sheet metal workers, and pipe fitters.

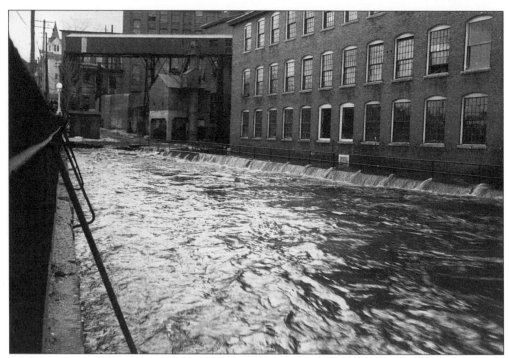

ASSABET RIVER FLOOD. On Sunday afternoon, there was just enough water in the Assabet River for a comfortable canoe ride. By the next evening, some 6 inches of rain had fallen, bringing the water in the river within a foot of its bank by the mill buildings.

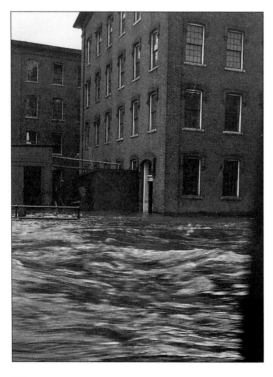

BANK OVERFLOW. By Tuesday morning, the water in the Assabet River was lapping over the edge of its bank. Within the next few hours, the water rose well over the bank.

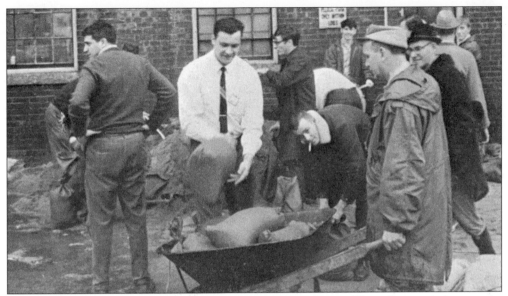

FILLING SAND BAGS. Digital Equipment Corporation employees fill sandbags to help stem the Assabet floodwaters. Several thousand sandbags and 60 pairs of boots were purchased by Digital in an all-out fight to keep the flood from causing any damage to their operations. All through the day and well into the night, employees filled sandbags that were used to keep the river waters at bay.

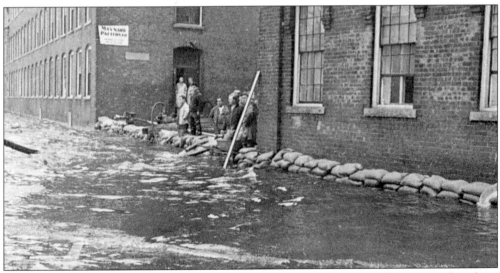

BUILDING A SANDBAG BARRIER. A sandbag dam was built across the courtyard and six tremendous pumps were used to pump the water out of this courtyard and to protect the buildings that contained Digital's production equipment. The river reached its peak at 4 a.m. Wednesday morning, and then it finally started to drop. By that night, it was just a few inches over the bank, and soon it was fully contained within its bank. Digital's Building No. 11 was unharmed, and production continued without interruption.

Your Dollars Go Further During Arthur's

OCTOBER SALE

We Need Room For Xmas

5 Pc.
Kitchen Sets
$69.50

BABY
Diaper Bags
Reg. $3.95
$1.98
While they last

Doll
Carriages
Reg. $18.75
$11.88

FIBRE
Scatter Rugs
Reg. $3.79
$1.29
All colors

Play Yard and Play Pad
Reg. $21.45
$15.50
Complete

Birch Crib
Complete with mattress
$37.95
Special

Lock Rocker
$49.47

Repossed TV 21" Table Mode
$150.00

Whirlpool
Dryer
$100.00
Extra Special

2 pc Maple Den Set
With Tweed Chair
$88.89

Extra Chair
$29.95

Automatic
Washers
$125.00
and up

Unfinished Furniture
3 drawer chest - $10.88
4 drawer chest - $12.41
5 drawer chest - $14.41
BOOK CASES
36 drawer $9.47

Vanity Tables
$8.88
SHOP - LOOK - SAVE!

Colonial
Cricket Chairs
$16.44

Bassinet
Complete with mattress
$10.88

Come in and
hear a demonstration

Peak output

ZENITH STEREO
of famous
80 watts

Norge 30"
Gas Range
$119.95

40" Norge Range
with center grille
Was $399.95
$239.95

Arthur's Furniture & Appliances
Mill Bldg. #12 146 Main Street Maynard

ARTHUR'S FURNITURE & APPLIANCES. This advertisement shows some of the furniture and appliances and the prices at which they were being sold at Arthur's, located in mill Building No. 12.

Five

DIGITAL EQUIPMENT CORPORATION

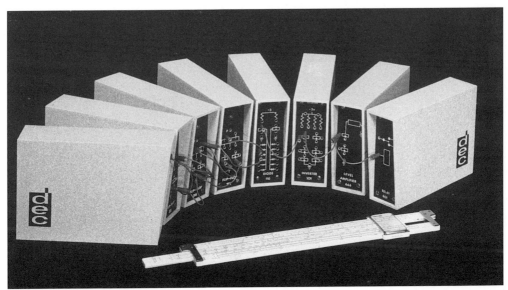

DIGITAL'S FIRST PRODUCT. Kenneth H. Olsen, who attended Massachusetts Institute of Technology and worked there as an engineer, came to the Maynard Industries Mills to start a company that would produce a small computer unlike the large ones that were then common. The first product that his company came out with was a series of transistorized, digital logic modules for use by research labs at a time when both transistors and the use of digital logic were emerging technologies. (Samuels.)

KENNETH H. OLSEN. Kenneth H. Olsen founded Digital Equipment Corporation in 1957 and served as its president until his retirement in October 1992. Under his direction, Digital grew from three employees in 8,500 square feet of leased space in a corner of an old woolen mill to the world's leading supplier of networked computer systems, software, and services. Prior to founding Digital, Olsen spent seven years on the staff of the Massachusetts Institute of Technology Digital Computer Laboratory. His activities there included serving as a leader of the section of the MIT Lincoln Laboratory that designed and built the MTC computer used in the SAGE Air Defense computer design program, and he supervised the building of the high-performance, transistorized digital computers, the TX-0 and TX-2, which set the standard of comparison for transistor-circuit performance.

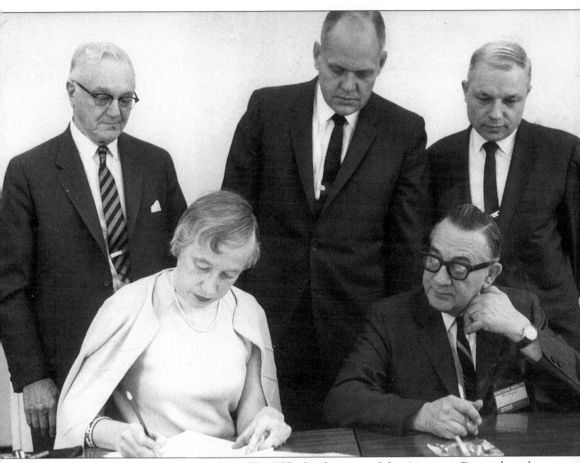

STARTING A NEW COMPANY. On May 27, 1957, the directors of the American Research and Development Corporation of Boston agreed to fund the implementation of a proposal submitted by Kenneth Olsen and Harlan Anderson that would start Digital Equipment Corporation. The first phase of that plan was to produce digital test equipment for sale to laboratories and schools and to design a general purpose, transistorized digital computer. The second phase, to be started when the first phase became profitable, was to build and sell the general-purpose computer designed in phase 1. Pictured here, from left to right, are the following: (front row) Aulikki Olsen, the wife of Ken Olsen, and unidentified; (back row) General Doriot, Ken Olsen, and Harry S. Mann.

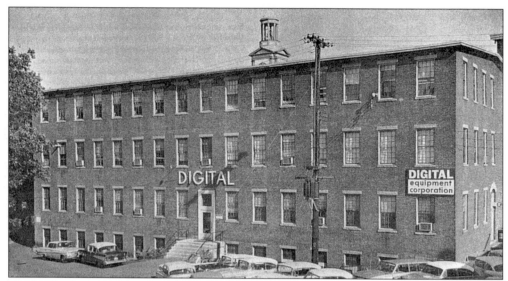

DIGITAL'S FIRST HOME. In 1957, Digital Equipment Corporation opened its doors for business in 8,680 square feet of the second floor of Maynard Industries Properties mill Building No. 12, shown here. The company later expanded into the third floor. The first floor was occupied by Arthur's Furniture.

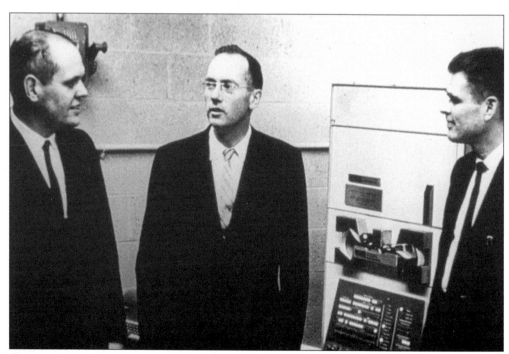

OLSEN, OLSEN & ANDERSON. Shown here, from left to right, are Kenneth Olsen, his brother Stan Olsen, and Harlan Anderson, the people who started Digital Equipment Corporation. Ken Olsen admits that he picked Maynard as the site for the new company because the rent was low and the people were not afraid of hard work. Digital rented the second floor of mill Building No. 12 for 25¢ a square foot and the third floor for 15¢ a square foot.

102

BEFORE. This photograph shows the mill space that Digital decided to rent—before the company moved into it in 1957. Digital originally occupied 8,680 square feet on the second floor of mill Building No. 12.

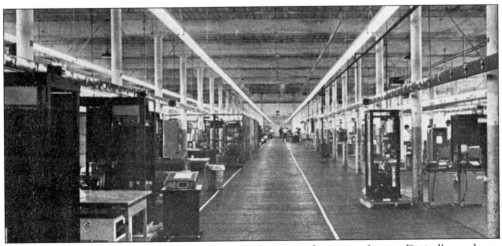

AFTER. This photograph shows the mill space being used to manufacture Digital's products. Digital signed a three-year lease for this space at a monthly rental of $300. Digital continued to grow, and within 17 years, bought the complete mill complex for its operations at a price of $2.25 million.

TOM DUGGAN, OLDEST EMPLOYEE. Tom Duggan, Digital's oldest employee, recently spoke of his early days at work: "When I first came to Digital, I worked in the mill in Building No. 5 on the fifth floor. I had been in the building before, when I was a kid. I would take my father's lunch and my uncle's lunch to them when the American Woolen Company was there. In those days, you'd hear the whistle blowing just before seven, then you'd hear all the machinery start up all at once."

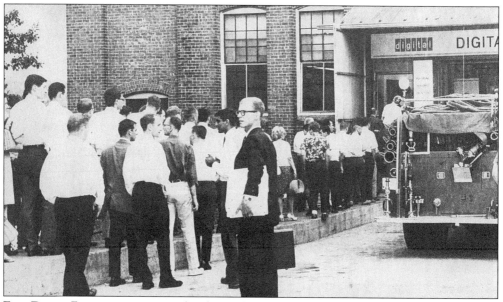

FIRE DRILL. Everyone was required to leave the plant during fire drills, which were scheduled periodically. Here, the occupants of Building No. 5 wait for the all-clear signal.

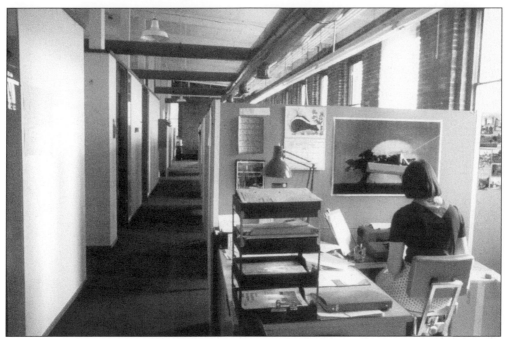

HALLWAY OFFICE. The wide hallway that was carved outside the engineer's cubicles was used for the secretary stations that supported the engineering and administrative staff.

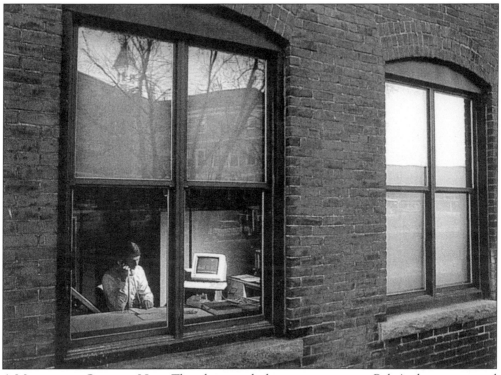

A MIXTURE OF OLD AND NEW. This photograph shows a programmer, Bob Anderson, wrapped in a cocoon of the old mill buildings, developing software for the Digital line of computers.

EARLY DIGITAL EMPLOYEES. Kenneth Olsen, president of Digital Equipment Corporation, dictates information to typist Diane Mulcahy. According to Olsen's description of the early days: "We did everything ourselves. My wife cleaned toilets and my brother Stan and I were the general purpose handymen, developing our early production equipment ourselves. Maynard was a great place to buy supplies since there were four hardware stores here and a well-stocked five-and-dime."

SELECTRIC ARTISTS. Here, two secretaries discuss their work at the Digital facilities in mill Building No. 12. Desktop computers and word processors had not yet been developed, and almost all secretary stations were equipped with an IBM Selectric correcting typewriter.

SUCCESSFUL MODULES. Digital's first products were logic modules enclosed in an extruded aluminum wave guide. They were rugged indeed. The circuits were negative-logic build with surface-barrier germanium transistors, which could run at 5 megahertz. There was no other product on the market like it at that time. The modules time line is as follows:

1957: 100 Series lab (5 MHz)
1959: 1000 Series system (500 kHz)
1960: 3000 and 5000 Series lab (10 MHz)
1961: 4000 Series system (500 kHz - 1 MHz)
1961: 6000 Series system (10 MHz)
1963: 8000 Series (30 MHz)
1964: Blue Flip Chip (10 MHz)
1965: Red Flip Chip (1 MHz)
1967: K Series industrial (100 kHz)
1969: M Series for computers

MEMORY TESTER 1516. The first systems Digital made were memory test systems to check the core stacks that were the memories used at that time. The technology used in these test systems were later used to build memories for Digital's computers. The 1516 memory test computer was designed and built to test the Whirlwind Computer's core memory.

MEMORY TESTER
1516

MEMORY TESTER 1521. The test equipment business was considered by Digital to be a stepping-stone to eventually building general-purpose computer products since they would share the same general circuits. Both Kenneth Olsen and engineer Dick Best patented many of the circuits that were involved in the memory test systems.

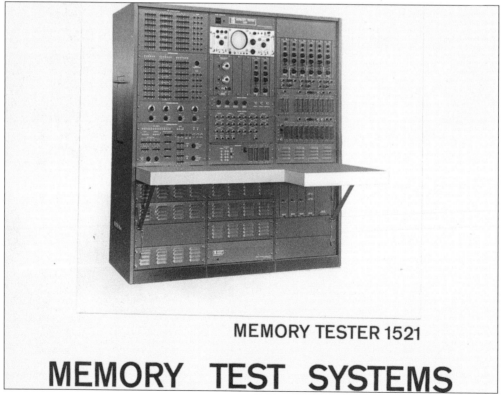

MEMORY TESTER 1521

MEMORY TEST SYSTEMS

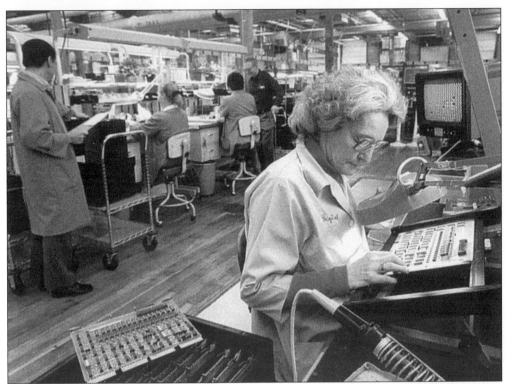

EARLY PRODUCTION LINE. The production line took many people to arrange the parts on the computer cards and then to solder and to install them. The open-beamed ceiling and bare wood floor of the old woolen mill days still provides the enclosure for the new technology.

GIVING BLOOD FOR THE COMPANY. Digital president Kenneth Olsen was the first to give blood in the company's Red Cross blood drive. Just because he was lying down and giving blood did not prevent him from continuing to do company business.

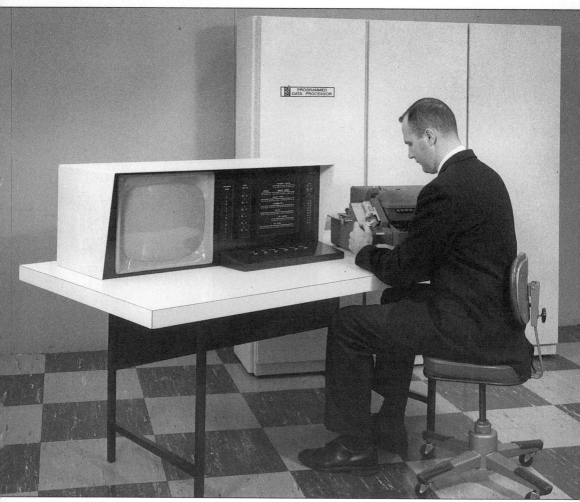

THE PDP-1 COMPUTER. Digital demonstrated its prototype PDP-1 (programmed data processor) computer at the 1959 Joint Computer Conference in Boston. The whole show was buzzing about this fledgling company called Digital and its little machine, which cost less than $150,000. Nothing was so affordable at the time. The company called Bolt, Beranek, and Newman recognized the importance of the machine and bought the prototype right off the floor. The computer became popular in the fields of nuclear physics, chemical instrumentation, biomedicine, process and industrial control, and data communications. (Samuels.)

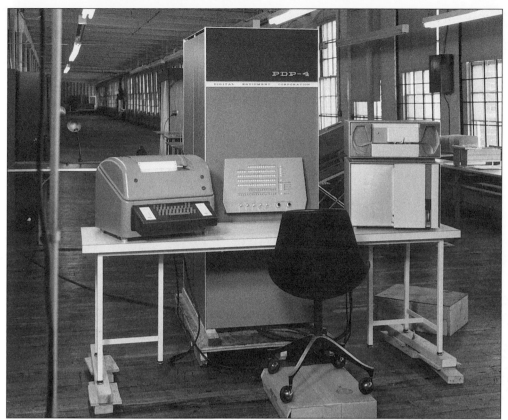

THE PDP-4 COMPUTER. Digital's PDP computer line was designed with the goals of interactivity, low cost, simplicity, and reliability. The computers in this 18-bit computer family are the PDP-1 of 1960, the PDP-4 of 1963, the PDP-7 of 1964, the PDP-9 of 1966, and the PDP-15 of 1969. (Samuels.)

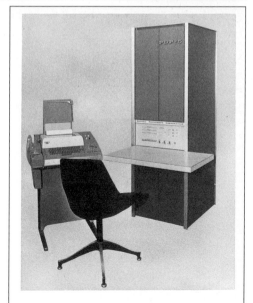

PROGRAMMED DATA PROCESSOR-5

THE PDP-5 COMPUTER. This computer's capacity and speed exceeded those of other computers available at the time, yet its price of about $400,000 was significantly less. (Samuels.)

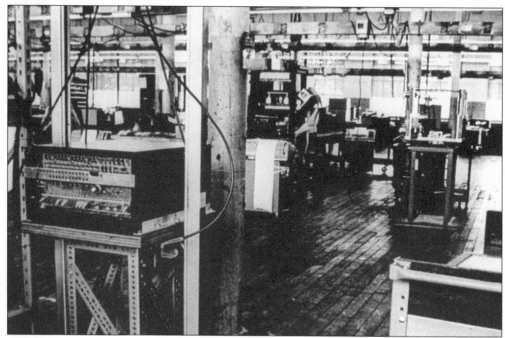

THE MANUFACTURING FLOOR. In 1965, Digital's employment was about 1,000 persons, most of them at the Maynard headquarters and main plant. By 1969, employment stood at about 3,500. In 1970, Digital had more than 5,000 people employed worldwide. (Samuels.)

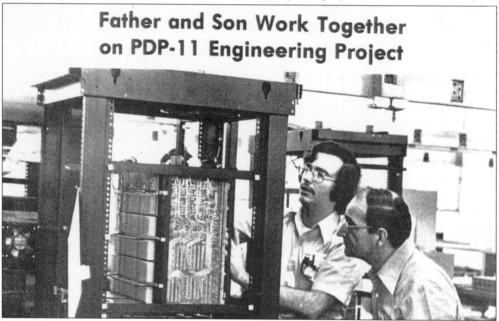

Father and Son Work Together on PDP-11 Engineering Project

FATHER AND SON WORKING TOGETHER. An interface design project for the PDP-11 computer recently enabled a father and son, both Digital employees, to work together as a team. Ken Adametz, a technician in the PDP-11 group, needed assistance with an unusual mounting. His father, Vince Adametz, is a methods planner and was called to assist with the custom mounting. The two worked closely on the problem and came up with a good solution.

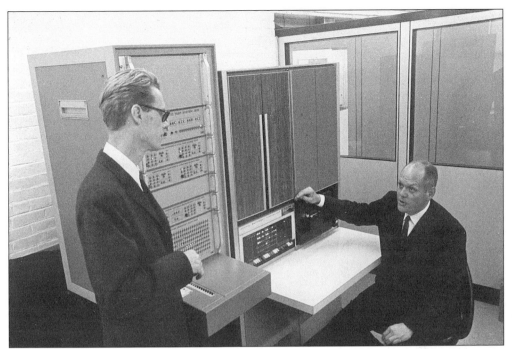

1000 PDP-8 Computers. The 1,000th PDP-8 computer built by Digital was purchased by Teradyne Inc. of Boston. Here, the keys to the computer are being turned over to Teradyne President Nick Dewolf by Digital President Kenneth Olsen.

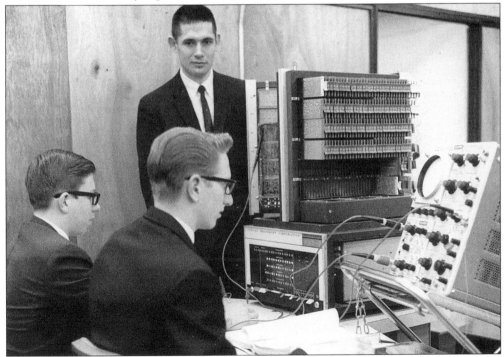

Teaching PDP-8 Computer Usage. Instructor Ed Hilton teaches a basic computer technology course for the PDP-8 computer to a group of future computer technicians.

DIGITAL'S LIBRARY. Shown here is the checkout desk and reference librarian for the library stacks at Digital Equipment Corporation. Besides having many engineering reference books, the library has a large collection of the latest technical periodicals to help keep the engineering staff fully informed. (Samuels.)

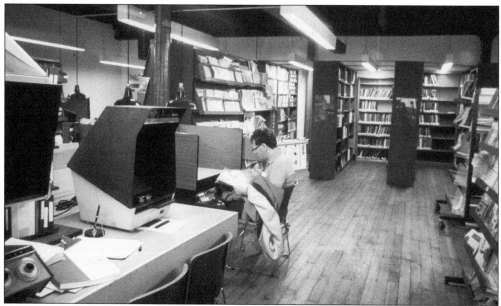

REFERENCE STACKS. These microfilm readers were located in the library area. Digital left the exteriors of its buildings largely unaltered, most of the ceiling open beamed, and the wood floors of the interior untouched, giving the company's offices and manufacturing areas a special look and feel unlike most other electronics facilities in the area or across the country. (Samuels.)

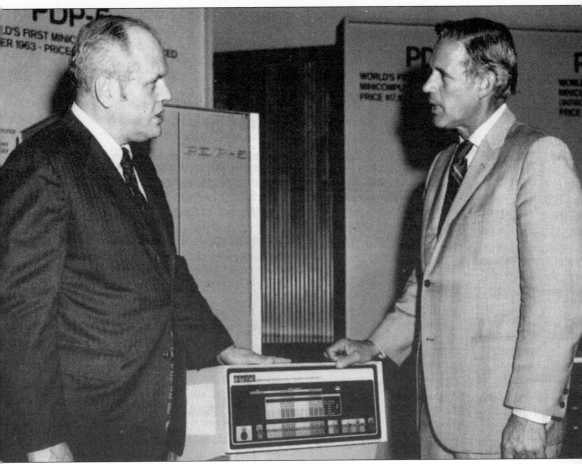

GOVERNOR SARGENT PROCLAMATION. Gov. Francis W. Sargent proclaims Maynard the Minicomputer Capital of the World during a speech given at Digital's annual meeting. The proclamation also declares Massachusetts the Minicomputer State.

CELEBRATION OF 25 YEARS. October 26, 1982, was a special day in which Digital celebrated its 25th anniversary. It started with a breakfast for 25 employees, one from each year of operation. Next, a tour by the officers was made to all the departments located in the mill buildings. In this picture, from left to right, president Kenneth Olsen, vice president Jack Smith, and vice president Henry Crouse admire a photo collage that was presented by the company's modules manufacturing department.

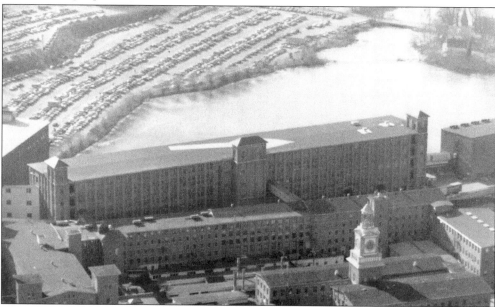

MILL FILLED AND OVERFLOWING. As Digital expanded and filled all the space in the mill complex, it had to open more and larger facilities in nearby towns to accommodate all of its departments. Eventually, the mills were reduced to holding only Digital's headquarter's offices. Finally, Digital relocated its headquarters in early 1994 and sold the giant mill facility to Franklin Lifecare Corporation in November 1994.

Six

CLOCK TOWER PLACE

NEW BEGINNING. On January 1, 1998, the 150-year-old Maynard Mill entered its next phase in anticipation of the 21st century and the third millennium. On that day, a new partnership team calling itself Wellesley-Rosewood Maynard Mills L.P. became the owner and manager of the 13-building, 1.1-million-square-foot complex. At the same time, the new partnership approved a different name for the mill for the purposes of everyday operations and marketing: Clock Tower Place. The new name was selected in honor of the 107-year-old town clock, which had been constructed at a high point within the Maynard Mill and then donated to the Town of Maynard in honor of Amory Maynard, the founder of the town and the mill. (Mullin.)

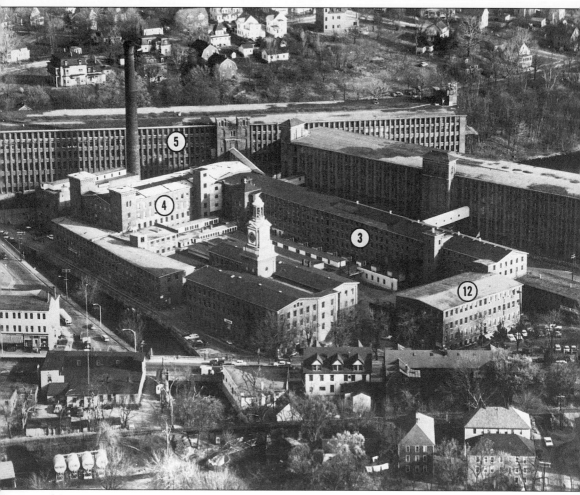

MILLPOND VILLAGE. Prior to Clock Tower Place's purchase of the mill buildings, Franklin Lifecare Corporation purchased the Assabet Mills complex in November 1994 from Digital Equipment Corporation in order to convert the buildings into a senior citizen community. Plans for the community called for apartments with all maintenance services tended to and meals and health care provided. The plans for this unique use of the mills were drawn up by Bergmeyer Associates Architects, and the name Mill Pond Village was given to the project. Plans were shelved after funding fell through, and the mill buildings remained unoccupied until Clock Tower Place purchased the facility.

CLOCK TOWER PLACE
MAYNARD, MASSACHUSETTS

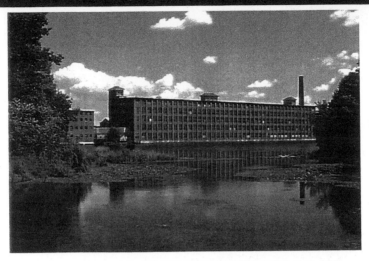

1.1 MILLION SQUARE FEET FOR LEASE

Centrally located in the western suburbs at the triangle formed by the intersection of Routes 117, 27 and 62 is Clock Tower Place. This 1.1 million square foot historic mill complex is poised to be the suburbs' most unique campus style business park. Set amidst picturesque Maynard town center and its surrounding amenities, Clock Tower Place offers an urban business environment in a suburban stress free atmosphere. Clock Tower Place is sited on 45 acres and is surrounded by suburban Boston's most desirable residential communities offering access to a diverse labor pool.

Address:	Clock Tower Place
	Maynard, MA
Size:	Approximately 1.1 million square feet
Architecture:	Classic brick and exposed beam office and flex
	space.
SF Available:	800 to 200,000 + square feet
Term:	Up to fifteen (15) Years
Rental Rates:	Starting at $13.95 per square foot gross
Telecommunications:	Redundant fiber optic infrastructure
Parking:	Up to 4 cars per 1,000 RSF
Planned Amenities:	Full service cafeteria, health club, daycare, ATM,
	Conference Center and on-site management and
	security

CLOCK TOWER PLACE FOR LEASE. This advertisement promotes the advantages of leasing industrial space in the new Clock Tower Place. (Mullin.)

MONSTER.COM. The company Monster.com was one of the first companies to lease space in Clock Tower Place. It moved 135 people into the fifth floor of Building No. 5 in June 1998. The company is headquartered in Maynard and Indianapolis, Indiana, and is a nationwide job-filling company, connecting employers with qualified individuals. The larger departments within the company are creative, marketing, product development, alliances, field sales, and telesales. (Monster.)

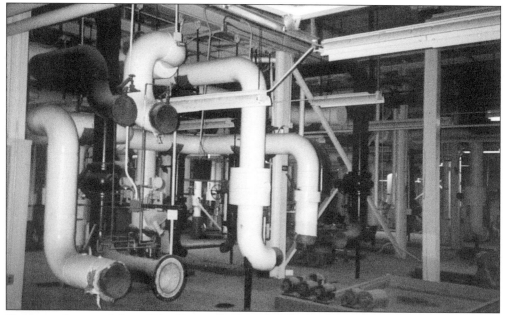

OCTOPUS. In one of the mill buildings, obsolete plumbing awaited the new millennium for its day to be recycled. (Boothroyd.)

KEN OLSEN AUDITORIUM. The modern Ken Olsen Auditorium and Conference Center within Clock Tower Place was opened and dedicated to one of the computer industry's most respected pioneers. The opening ceremony included Maynard town officials, former employees of Digital, and the inheritors of the historic building, which had once been the home of the company that Olsen founded. (Mullin.)

MULBERRY CHILD CARE. The Mulberry Child Care and Preschool opened at 4 Clock Tower Place under the directorship of Rob Hatch. The center offers child care not only for parents who work in the mill but also for others who live in the area. (Boothroyd.)

PLAYGROUND. As a sign of the times, this day-care playground is found within the mill complex. It is part of the Mulberry Child Care facility located within the mill. (Boothroyd.)

OLD MILL CHIMNEY. This red brick chimney, 207 feet high, was erected in 1886. Obsolete today, it has been equipped by a company called Nextel with an antenna array to carry cellular telephone conversations. (Boothroyd.)

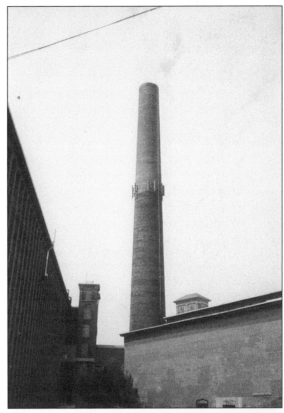

OLD MILL ARTIFACTS. In the main lobby at Two Clock Tower Place is a display of old mill artifacts, including tools and some of the machinery used during the days when the mill produced wool cloth and blankets. (Boothroyd.)

MANY NEW TENANTS. At the end of the 20th century, the 19 tenants who filled much of the space of the giant mill buildings are Monster.com, Bell Atlantic, Electronic Data Systems, the New England Restaurant Group, Corporate Chefs, Mulberry Day Care Center Inc., EBI Companies Inc., FlowMetrix, Harpell-Martins and Company, Home Life Medical, ACSIA, North America Power, the Powell Flute Company, Security Life of Denver, SoftLock.com, the Sudbury Valley Trustees, TMP-Worldwide, Techs Corps, and the Yacobian Group. (Boothroyd.)

BELL ATLANTIC. The Bell Atlantic telephone company leased office space and storage space at the new Clock Tower Place. (Boothroyd.)

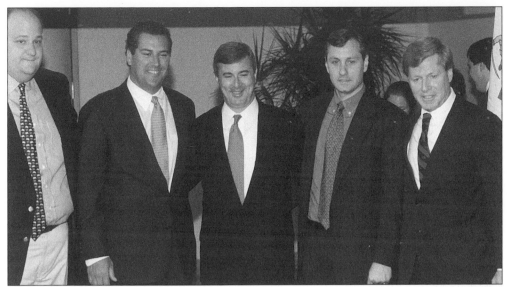

DEDICATION OF CLOCK TOWER PLACE. A reception was given by the governor of Massachusetts at Clock Tower Place in Maynard on Tuesday, October 13, 1998. From left to right are Robert E. Bumato, partner of Clock Tower Place; Robert W. MacNamara, project manager, Clock Tower Place; A. Paul Cellucci, governor of Massachusetts; William Depierri, partner, Clock Tower Place; and Joseph W. Mullin, partner and public affairs director of Clock Tower Place. (Melone.)

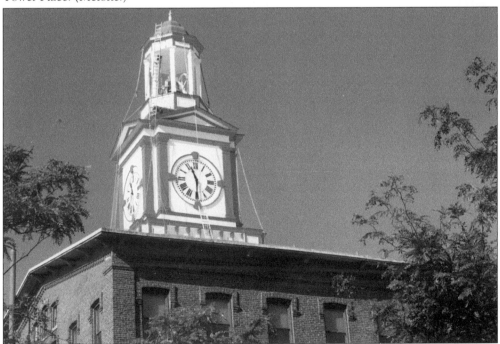

CHANGING COLORS. The original color for the clock at Clock Tower Place was a dark red and white. In 1942, when the United States was entering World War II, the clock was painted gray and white in order to make it harder for airplanes to spot. A townwide vote in 1998 favored repainting the clock its original Victorian colors. (Boothroyd.)

POWELL FLUTE COMPANY. Since 1927, Verne Q. Powell Flutes has been transforming precious metals and woods into beautiful hand-made flutes and piccolos, which project the rich, colorful sound distinctive to Powell. The distinguishing characteristics of the Powell flute originated with the company's founder, Verne Q. Powell, who instilled in his craftspeople an artistic philosophy of the Powell unique sound and feel. Today at the Powell factory, now located at Suite 300 at Clock Tower Place, more than 50 flutists, artists, machinists, and engineers, under the guidance of the company's current owner Steven Wasser, share their collective knowledge and skills in the construction of each flute they make. (Powell.)

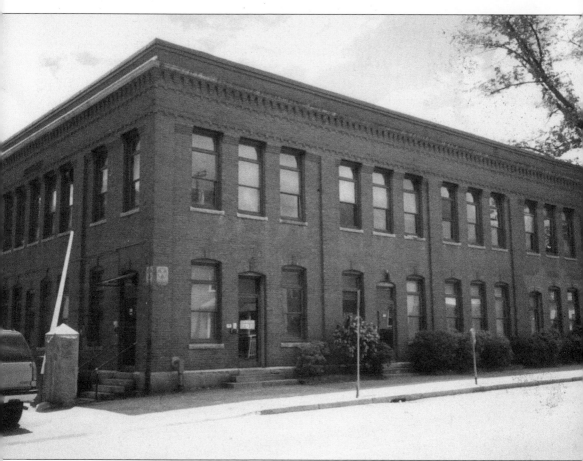

TOWN HISTORICAL MUSEUM. Partnership agreements were made with Clock Tower Place that included the town approving a 15-year tax-increment financing agreement. As part of the agreement, the state designated the town and Clock Tower Place an Economic Target Area, and the federal government is providing the funding for a municipal garage on the property for use by tenants and others. Among the numerous commitments made by Clock Tower Place in return for these agreements is the transfer to the town of a 7,000-square-foot building known as the Paymaster's House Building, shown above, for the purpose of developing a town-run historical museum at the historical mill site. (Mullin.)

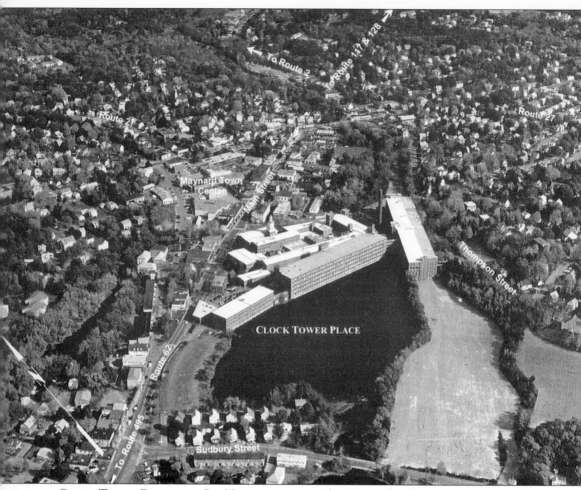

CLOCK TOWER PLACE AND ITS NEIGHBORHOOD. The Maynard Mill and the town of Maynard are now perceived to be situated within one of the most desirable regions to live within the state and around the country, both in terms of young families starting out and of senior managers and professionals with personal lives already well established. At the end of the 20th century, "Happy Days are Here Again," thanks to the efforts and achievements of the men and women who settled in Maynard and worked at the mill throughout the years. (Mullin.)